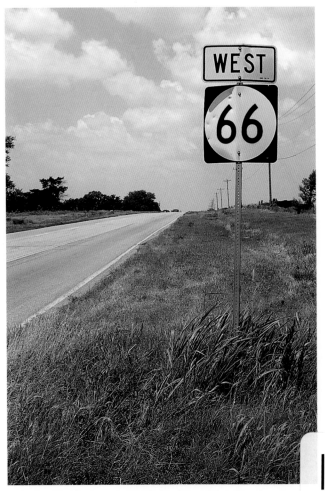

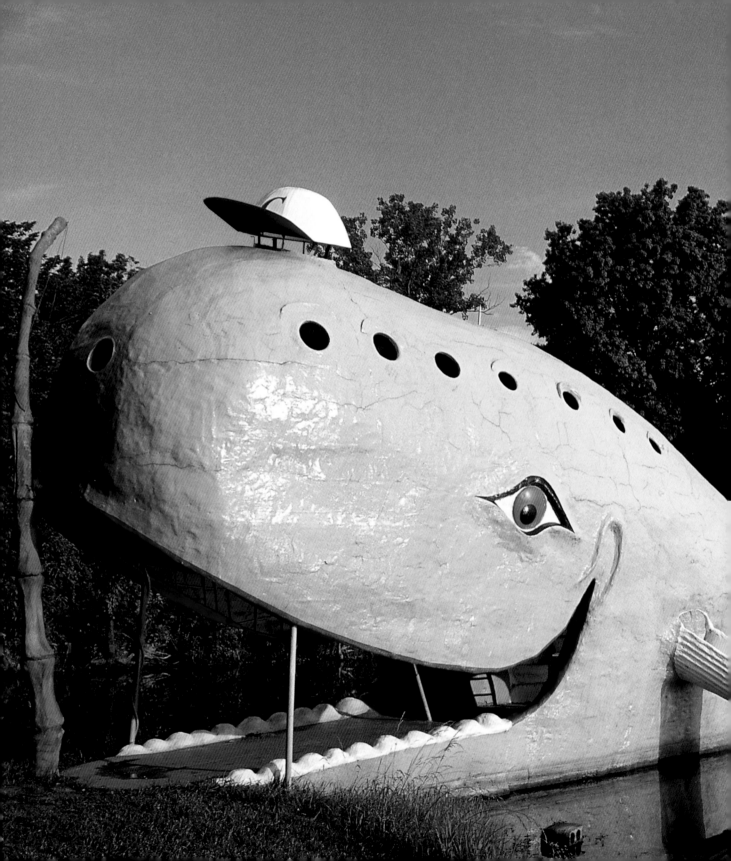

Route 66

TIM STEIL
WITH PHOTOGRAPHY BY JIM LUNING

Voyageur Press

First published in 2000 by Voyageur Press, an imprint of MBI Publishing Company, Galtier Plaza, Suite 200, 380 Jackson Street, St. Paul, MN 55101 USA.

The information in this book is true and complete to the best of our knowledge. All recommendations are made without any guarantee on the part of the author or Publisher, who also disclaim any liability incurred in connection with the use of this data or specific details.

This publication has been prepared solely by MBI Publishing Company and is not approved or licensed by any other entity. We recognize that some words, model names, and designations mentioned herein are the property of the trademark holder. We use them for identification purposes only. This is not an official publication.

MBI Publishing Company titles are also available at discounts in bulk quantity for industrial or sales-promotional use. For details write to Special Sales Manager at MBI Publishing Company, Galtier Plaza, Suite 200, 380 Jackson Street, St. Paul, MN 55101 USA.

To find out more about our books, join us online at www.VoyageurPress.com.

Edited by: Keith Mathiowetz
Designed by: Tom Heffron
Layout by: Todd Sauers and Dan Perry

Library of Congress Cataloging-in-Publication Data
Steil, Tim
 Route 66 / Tim Steil
 p.cm—(Enthusiast color series)
 ISBN 978-0-7603-0747-2 (pbk. : alk. paper)
 1. United States Highway 66. I. Title. II. Series.

HE356.W37 S74 2000
388.1'0973--dc21

On the front cover: A collage of photographs taken along America's Main Street. From Illinois to California, Route 66 offers a wonderful array of roadside architecture, gift shops, and scenery.

On the frontispiece: Pushing ever westward toward the Texas border, outside Elk City. Though officials are still hacking away at the old road, much of Route 66 is still findable—and drivable—in Oklahoma.

On the title page: Just outside Catoosa, Oklahoma, the Blue Whale swimming hole drew locals for decades. Though it is no longer open, a new coat of paint restores the attraction to its former glory.

On the back cover: The colorful neon sign of the Blue Swallow Motel in Tucumcari, New Mexico, beckons weary travelers.

Printed in China

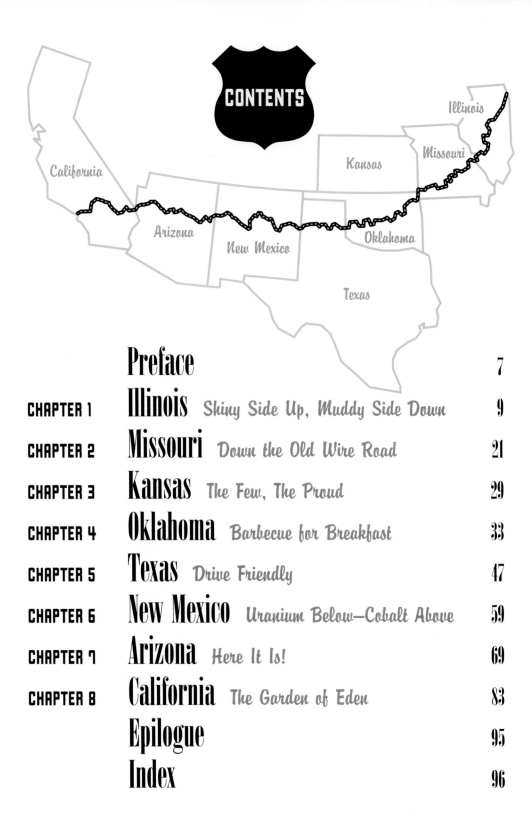

CONTENTS

Preface

I suppose there are people in this world who are unaffected by the smell of diesel smoke. That, leaning against a truck stop gas pump at 3 AM, a warm summer breeze full of corn pollen, and exhaust fumes bathing them would not give them an urge to purchase a tall coffee, jump on the nearest highway and drive until daylight just to see what's there. I am suspicious of them.

There are few things in life as alluring as a road trip, and few roads beckon as seductively as Route 66. Stretching halfway across the country to the Pacific, it is a road born of necessity and sustained by sheer will. There are more scenic trips, perhaps, but none more encompassing of the twentieth-century American experience than Route 66.

There has been much written about this road over the years. There are many wonderful books, maps, and videos out there that go into far greater detail than I have room for. But many only talk about Route 66 in the past tense, as if it ceased to exist simply because fewer people travel it today. Or worse yet, they tend to look at everything along the road through teary eyes, lamenting the sorry state of things since the interstates went in. That's unfair.

Yes, there are whole sections of the road that are gone, where the pavement simply stops and turns into a muddy field. There are restaurants and motels and gas stations and entire towns that dried up and blew away when the interstate bypassed them. I've peered through their dusty windows, picked through their old business records, and been chased down their abandoned main streets by dogs who, apparently with nothing better to do, take great solace in watching overgrown men run and swear at the same time.

So while you'll find a bit of familiar history inside, there are also things I've left out—stories others have already told better. I tried to find some new faces and places along the way, and perhaps take a more thoughtful look at the ones we all know. It's easy to get caught up in the nostalgia and kitsch of what Route 66 was 50 years ago, but I am just as interested, if not more so, in what it is today.

I did a lot of research before leaving on this trip. I read all the books, watched all the documentaries, and studied the maps. Though I left with a good historical grounding, it did little to actually prepare me for the enormity of the experience. I've traveled extensively in my life—all over the world—but driving Route 66 from end to end has been the absolute journey of a lifetime.

I met beautiful, kind people who would give you their last dollars and the shirts off their backs if they thought you truly needed it, and toothless, drunken rednecks who would gladly cut your throat from ear to ear simply because you're not "from here." But mostly I met average folks, respectful of one another and carrying on from day to day as best they can.

This old road is a subtle teacher, and the lessons I learned along the way will be with me forever. Anyway, glad you decided to come along. Don't mess with the radio.

—*Tim Steil*

During infrequent trips back to Arizona, famed artist Bob Waldmire is working on "the world's largest map of Old Route 66" outside of Meteor City.

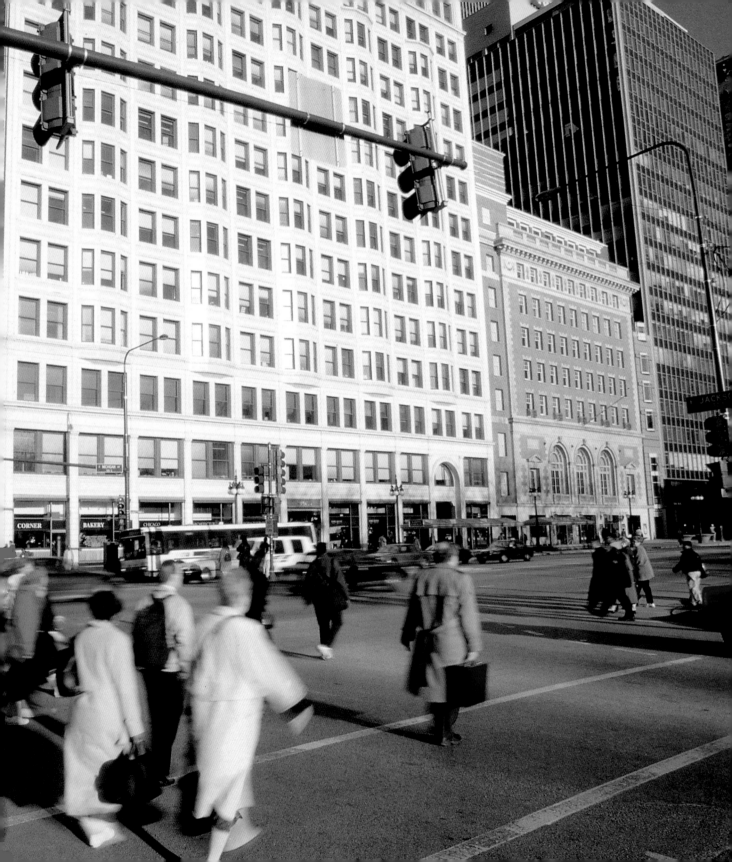

Downtown Chicago is an eerie place at sunrise. There is a brief window where the shifts of the night owls and overachievers don't quite meet, and the Loop is almost still. It's 6:30 in the morning, and between the long shadows there are already crowds of people scurrying along the sidewalks and across the streets. On Michigan Avenue you can hear a faint hum of traffic from Lake Shore Drive under the cabs' horns and cops' whistles. In two hours there will be hundreds of thousands of people jamming into offices and onto roadways and sidewalks.

Rolling west out of the Loop and onto Ogden Avenue you get a glimpse of a different side of Chicago. The shiny steel and glass canyon gives way to vacant lots and corner bodegas where more business gets done out on the sidewalk than in the store. Storefront churches and liquor stores sit in uneasy proximity as Route 66 slices through the city's southwest side. There are few reminders of the old road here—certainly no souvenir stands. While we tend to think of places affected by the closing of Route 66 as being rural, its decommissioning was as devastating to the inner city as it was to small-town America. If here, along the Chicago-Cicero border they seem to miss it less, it is because they have lost so much of everything.

But by the time you get to Harlem Avenue things perk back up. The brown-and-white historical markers reappear, guiding you through the last of the exurban sprawl of Chicago and onto Interstate 55 for a stretch. Here the southbound lanes are old Route 66, and just off one of the first exits is Dell Rhea's Chicken Basket.

Dell Rhea's Chicken Basket

As you walk in, Pat Rhea is seated at the bar, one eye on the television, the other alternating between a waitress and the *Wall Street Journal*. He listens intently to the phone cocked to his left ear while he waves to someone walking in the door. The garrulous owner of Dell Rhea's Chicken Basket is a busy man. He is also a lucky man.

The restaurant his father took over in the early 1960s is an oddball along old 66—a survivor. It sits a few hundred feet from Interstate 55 in Willowbrook, Illinois, dually insulted by a frontage road address and maze of chain hotels surrounding it.

The chicken comes in a light batter, and the live music comes hot and greasy. When we visited, Pat Smillie, a Scotsman with a voice like Delbert McClinton and a build like a keg of beer, was belting out Parliament/Funkadelic covers and dancing off his 102-degree fever.

CHAPTER 1

Illinois

Shiny Side Up, Muddy Side Down

You can't get there from here. Though Michigan and Jackson is technically the beginning of Route 66, Jackson runs one way east. To leave downtown Chicago you must jog one block south and turn west on Adams.

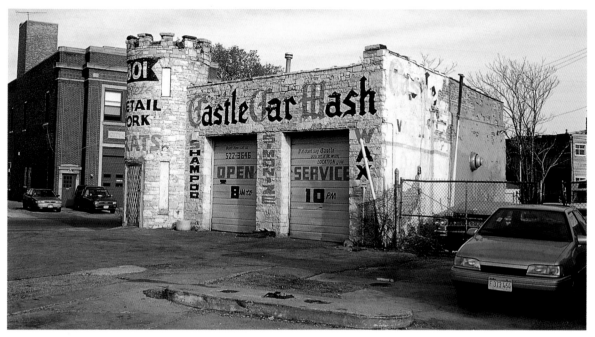

Route 66, US 34, or Ogden Avenue? Regardless, the Castle Car Wash does little business in Cicero, Illinois. Once home to mobsters such as Al Capone and Frank Maltese, the suburb has never been able to live down its "wide-open" reputation.

The Chicken Basket is as old as Route 66 itself. In 1927 Irv Kolarik ran a gas station across the street. Inside he had a little counter and a few booths, and soon realized he liked cooking better than getting his hands dirty at the gas station. Four sisters from a nearby farm offered to teach him how to fry chicken and work for him, if he would buy his chicken and eggs from their farm.

The sisters eventually married and left Kolarik the recipe and the business. He closed his repair bays and turned them into additional dining rooms, but a dispute with his landlord forced him out of the building. He sold the business to the landlord, and immediately bought the property across the street. A year to the day later, when a noncompete clause had expired, Kolarik opened the "Nationally Famous Chicken Basket" in its current location. That night Dell Rhea, who ran the Woodbine Restaurant up the street, closed up and personally led all his customers over.

"It was his way of paying tribute to the new owner, and saying welcome to the neighborhood," says Pat. In an odd twist of fate, his father would end up buying the restaurant from Kolarik less than 20 years later.

Dell Rhea was well known and respected in the area and added his name to the business. His combination of charisma and connections soon turned the place around. A supper club in its finest classic sense, it became a favorite for locals and travelers.

While he has managers who handle the day-to-day transactions, Rhea is constantly tweaking the menu, monitoring his advertising and marketing plan, and eating chicken. The staff knows at any time he may walk in and check an order. In short time, you realize two things: Pat Rhea cares deeply about what he does, and a lot more thought goes into a fried chicken dinner than you ever considered.

Every place that serves fried chicken touts a secret recipe, and Rhea assures us he has one too. Though

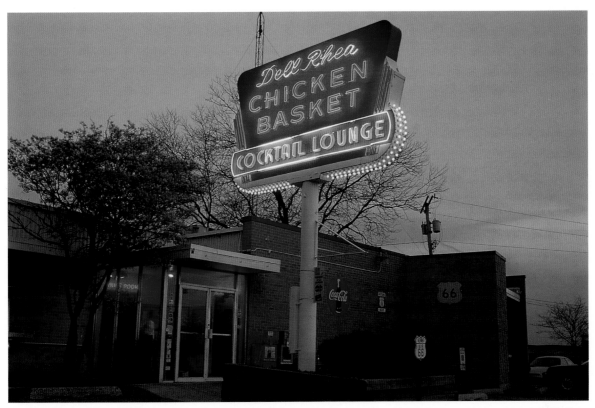

If you follow the signs carefully, you can navigate the maze of frontage roads it takes to find Dell Rhea's Chicken Basket. Inside Pat and Grace Rhea serve up hot food, good music, and Route 66 "Route Beer," bottled by a friend.

he won't be specific about ingredients he says there are some differences between his chicken and others.

"We season the meat. Most places only put seasonings in the batter. And we never use frozen chickens," he explains. "The size is very important as well. Too small a bird dries out when you cook it, and the bigger chickens tend to be fatty. We only use ones within a certain weight range."

Yet for all his passion and expertise, Rhea never intended to go into the family business. "I saw the way my parents had to work, and the sacrifices we had to make. We missed weddings, funerals, and all sorts of family obligations."

Though he had been accepted into an accelerated prelaw program at DePaul University, Pat attended a local community college so he could continue to work at the restaurant while he attended classes. And though he took classes in business law and management, he also enrolled in food service courses.

The Chicken Basket's reputation today is international. As Rhea describes a customer from the night before, who had the place recommended to him while waiting for a flight in London's Heathrow Airport, a waitress brings over a book in Japanese on Route 66 that a visiting couple wants autographed. He excuses himself to go talk to the couple, whose command of English is limited mostly to nodding and smiling.

"Stuff like that just gives me the chills," he says, taking a long pull on his drink as he sits back down a few minutes later. "Just gives me the chills."

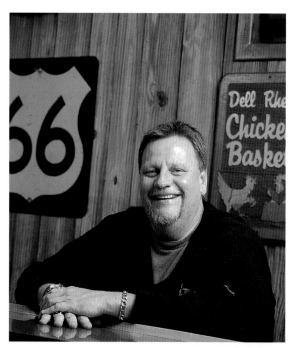

"I won't drive the interstate if I don't have to," says Pat Rhea. He got as far as Shamrock, Texas, on Route 66, where he and a friend schemed to buy the U-Drop Inn. Today Rhea is eyeing neighboring suburbs to open new locations and hopes someday to take the restaurant national.

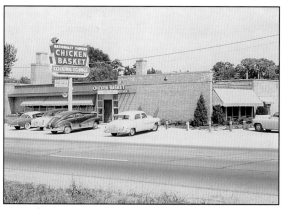

Circa 1950. Irv Kolarik's "Nationally Famous" chicken recipe actually came from four sisters on a nearby goat farm, who worked as cooks and waitresses. Despite being bypassed by Interstate 55, the Chicken Basket has been open in this location for over 50 years. *Dell Rhea's Chicken Basket*

Illinois Icons

Rolling into the widening prairie south of Dwight, the old road runs parallel to the older road, which, were it not for the grass growing through the cracks in it, seems to be in drivable shape. Just outside Towanda, Club 66 sits in humble defiance. Once a service station, the pumps and islands have been painted over in funky, park-bench green and the oil company sign replaced with a crudely rendered 66 logo. Inside, locals enjoy an early beer and the latest news from their neighbors, though no one is sure who owns the bright red Corvette parked on old 66 across the way. Yet another riddle on a lost highway.

The miles south of Bloomington are rich in Route 66 lore. Here, the Funk family has been tapping sugar maples since the 1800s. Their "sirup" (spelled that way to indicate it is made without added sugar) has long been a staple of travelers. And for those whose schedules don't permit a drive on the actual road, the Dixie Truckers Home offers a one-stop look at the history of Route 66.

J. P. Walters opened the original Dixie Truckers Home in a converted garage in 1928. It soon developed a reputation among long-haul truckers for its good food and southern hospitality. Even throughout the Depression, as many businessmen fell on hard times, Walters' cafe flourished. Soon, travelers were coming around the clock, and Walters decided to stay open 24 hours a day. The world's first truck stop was born.

In the 70-some years since, the Dixie Truckers Home has only closed once, when it was destroyed by fire in 1965. Still, as the remains of the building smoldered nearby, the pumps re-opened for business.

Next Page
So much for little green men. The Gemini Giant towers over Route 66 at the Launching Pad Drive-In in Wilmington. Next door, cars wait in line at the Route 66 Car Wash.

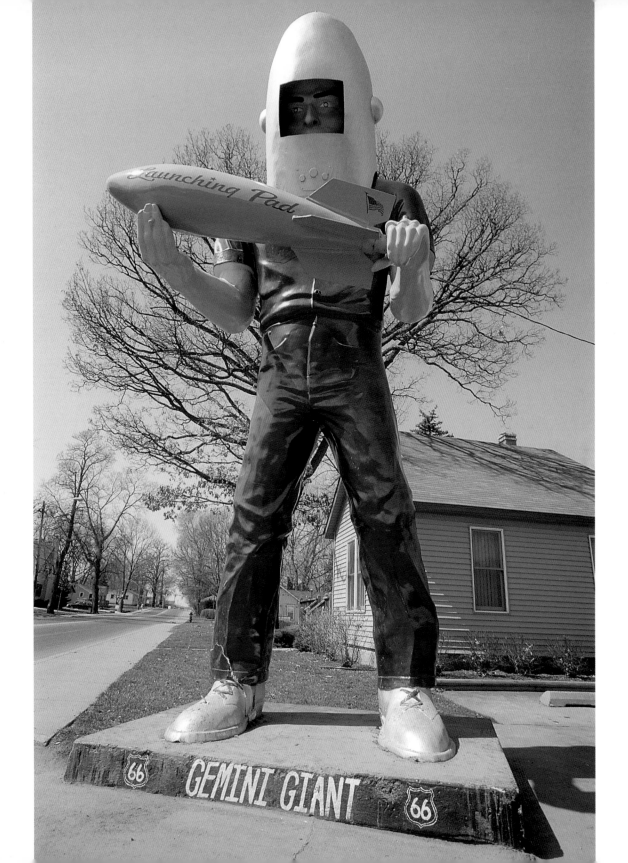

Businesses change along Route 66. What was once a modern gas station is now home to Club 66, a makeshift tavern.

The Dixie Truckers Home you encounter today is bright, clean, and sparkling new. Inside, an old-fashioned buffet is flanked by a retro soda fountain. There is a modern convenience store and gift shop, plus showers, arcades, and phones, amenities you probably don't realize the importance of unless you are a long-haul trucker. And tucked in back between the restrooms and the video arcade is the Route 66 Museum.

It's no more than a hallway, really, but in the 30 or so feet of glass-cased displays are some true gems. A Route 66 highway sign that was used in the filming of the television series of the same name sits beside sheet music of the Nat King Cole hit, "(Get Your Kicks on) Route 66," and a bowling league patch from a team sponsored by the Chicken Basket Restaurant, before it became Dell Rhea's Chicken Basket. And off to one corner is a large photo of a man in a tall chef's hat, sitting on a chair in the middle of a crumbling blacktop road. The road is Route 66; the man in the hat is Ernie Edwards.

For 54 years Edwards ran the Pig Hip Restaurant in Broadwell. Though it closed in 1991, he still lives next door, and is eager to talk about Route 66 with those who pass. When we rolled up late one afternoon, Edwards invited us to his home without reservation, merely noting that he thought it had been an awfully long time since someone had stopped by asking about 66.

Edwards escorts us into his breezeway office, festooned with Route 66 memorabilia and piled in the corners with books and magazines. It's as much a museum as that hallway back at the Dixie Truckers Home, and Edwards is its prize exhibit. The stories come freely—hungry families with only enough money for gas, but who left with full bellies and sandwiches for later, the truckers and musicians passing back and forth. He has a thousand of them. But in nary a one will you find Ernie Edwards anywhere but behind the counter of the Pig Hip.

Standing in front of the shuttered restaurant, with old 66 behind him, Edwards recalls giving

directions to a local state park, and describing its features to decades worth of travelers. "I'd never been there," he says with a hoarse laugh. "Not until after I retired, anyway."

Today, the road Ernie Edwards sunk his life into pays him back in kind. He gets a handful of tourists every week, mostly foreigners, stopping in to look at the Pig Hip and hear stories about the old days. He turns none away, and that activity is something inherently more valuable than money or fame to a man retired from such an active life.

From Many, One

We like to believe great people are different. Those who jet around the world building dams or sitting in plush offices commanding empires, we assume have stronger wills and higher IQs, better health, and more attractive children. They don't. What separates people who end up in history books from the rest of us is an obsession. Cy Avery's obsession was roads.

Cyrus Stevens Avery was born in Pennsylvania, and moved to what was then simply known as Indian Territory when he was a teen. After graduating from college he married and tried his hand at real estate and coal, and dabbled in the oil lease business with Harry Sinclair. After World War I he opened a service station and restaurant just outside of Tulsa. Now a successful businessman and community leader, Avery became involved in public service. Whether it was blind altruism or a vested interest in transportation, he found his niche in highway planning.

In 1925 Avery, who by then was an Oklahoma state highway commissioner, was appointed to the Joint Board on Interstate Highways, a federal committee convened to adopt a national highway numbering system.

"What the Joint Board was trying to do was identify the best existing roads at the time," says Richard Weingroff, a Federal Highway Administration liaison who has written widely on transportation

Long before cruise-control, drive-through windows, and rest stop vending machines, travelers relied on spots such as the Dixie Cafe for a hot meal. *Dixie Truckers Home/Illinois Route 66 Association.*

history. "Some states had adopted numbering for their own state roads, but nationally the roads had names. Everyone knew the Lincoln Highway, or the Jefferson Highway, or the Atlantic Highway or Pacific Highway; that's how they were listed on maps."

Route 66 and the entire grid wasn't so much built as it was imagined. Over the summer the Board studied maps, and traveled throughout the country getting input from local planners on how to connect the best roads.

"In some areas, the southwest in particular, there was only one way the road could go. If there was an established route through a mountain pass, for instance, you obviously weren't going to build a new one," Weingroff continues. But in some cases, the board had a number of options, and none of the commissioners were blind to the prosperity a steady stream of travelers could provide an otherwise rural area.

Next Page
Like an aircraft carrier in the middle of a cornfield, the Dixie Truckers Home hums with traffic 24 hours a day. Now operated by Mark and Kathy Beeler, the Trucker's Home also has locations in Effingham, Tuscola, and LeRoy.

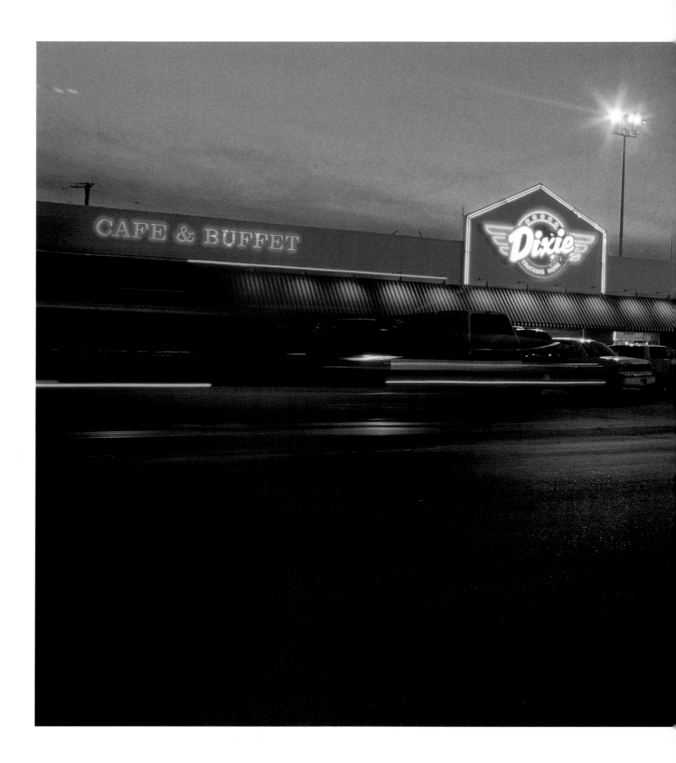

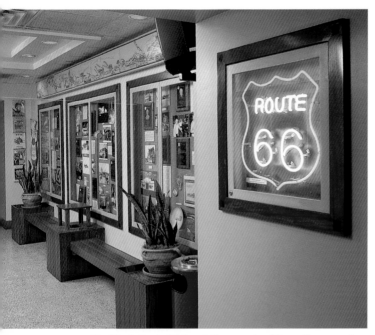

The Illinois Route 66 Association operates this small museum in a back hallway of the Dixie Truckers Home. What it lacks in space, it more than makes up for in traffic at the busy truck stop.

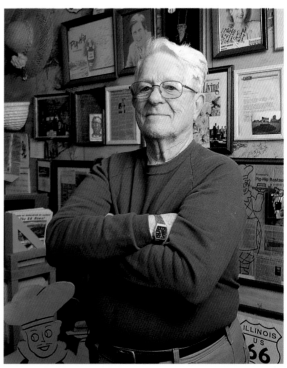

"The equipment was gettting old, and so were we," said Ernie Edwards, of his decision to close the Pig Hip Restuarant nine years ago. He would like to see it turned into a Route 66 museum.

At the time, there were no major through-routes passing through Oklahoma, and Avery was determined to bring one home. He picked the route from Chicago to Los Angeles, and made fast friends of the highway commissioners from Missouri and Illinois, whose states would also benefit.

The main east-west intercontinental routes all had numbers that ended in zero, and Avery wanted the status and traffic a main route would bring. So the Chicago-to-Los Angeles road was designated Route 60. When the Board turned in its plan in October, Kentucky Governor William Fields was not amused.

Fields looked at the grid, and saw Route 80, 70, and 50 all stretching westward from the Atlantic. But, as he looked for Route 60, which should have started in Virginia and cut through his state, the governor was dumbstruck. Route 60 started in Chicago, hundreds of miles to the north. Fields, who had served seven terms in Congress

before becoming governor, was a well-connected man, and wouldn't go down without a fight.

Avery and his counterparts in Illinois and Missouri fought to keep the main road designation, but in the end the Joint Board saw Avery's end run for what it was, and sided with Fields. The grid was redrawn, with Route 60 now starting in Norfolk, and running in fits and starts across northern Kentucky before joining the Chicago-to-Los Angeles route, now designated Route 66, in Springfield, Missouri.

Ironically, after fighting so hard for the highway to pass through his state, Fields was voted out of office the next year after proposing a massive bond issue to improve Kentucky's infrastructure. Avery, though dubbed "The Father of Route 66" by some, was a political appointee who also left office the next year. But as Avery

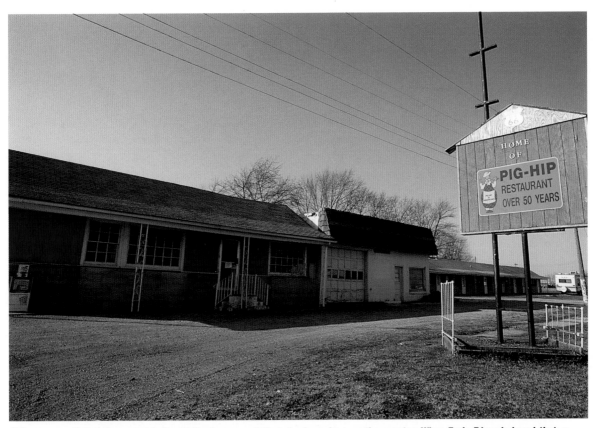

"Gimme one off that there pig hip," said the farmer, pointing at a large ham on the counter. When Ernie Edwards heard that, a light went on, and the Pig Hip sandwich was born. Edwards and his wife ran the restaurant for 54 years, before retiring in 1991.

faded from the national spotlight, Route 66's reputation began to grow.

"Today, we look back with nostalgia, and think about stopping at a teepee motel or something," says Weingroff. "But if you were a motorist back then, you weren't thinking of anything other than keeping a firm grip on the wheel. In reality, Route 66 was a narrow, two-lane road that until the mid-1930s was still compacted dirt in some areas. It was very unsafe."

But before it was even completely paved, Route 66 was becoming an American icon. In the early 1930s dust storms rolled across the southern plains killing livestock and crops, and burying farms in thick layers of powdery dirt. Already strained by the hardships of the Depression, thousands of families simply packed up and left to look for a better life. For most of them, that meant California.

In 1936 *The San Francisco News* commissioned a young novelist to write a series of articles on migrant workers. John Steinbeck, whose *Tortilla Flat* had just been published to wide acclaim, filed a seven-part series called "The Harvest Gypsies" that October. But the workers, many of whom had fled the Dust Bowl on Route 66, had captured Steinbeck's imagination, and those articles became the foundation of what some consider to be his greatest work, *The Grapes of Wrath*.

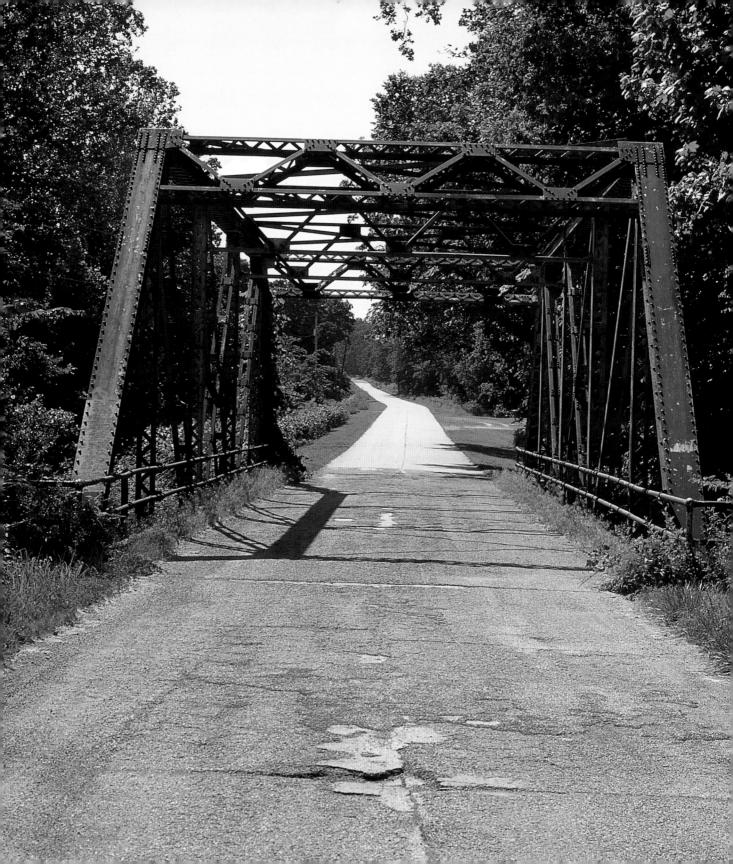

No matter how many times you do it, crossing the Mississippi River always feels momentous. The flat, muddy expanse moves swiftly past St. Louis, punctuated by throws of driftwood and riverboat casinos. If Chicago is a city on the make, then St. Louis is a city on the verge. It has always chugged along dutifully, producing Chuck Berry, the occasional baseball player, and an ocean of beer, but has never quite managed to distinguish itself as a world-class city.

Route 66 took several different routes through St. Louis over the years. With a good map and a loose schedule you can wind through them, but many of the neighborhoods have deteriorated, making it both faster and safer to follow Interstate 270 around the northern edge of the city until it splits off to Highway 100 west.

Rolling out of St. Louis and into the verdant hills to the west you enter the other Missouri. Far from the ballparks and breweries, Route 66 follows the vestiges of what was once the Osage Trail. In later years telegraph lines went through, and the county highways that were stitched together into

Route 66 were known as the "Wire Road." And while you are technically headed west, a drive through central Missouri begins to feel more like a drive straight south.

What's left of the old highway is a hodge-podge of service roads and crumbling blacktop. Though you couldn't go as far as call it tree-lined, what trees remain are fine ones. Old oaks and willows line the roadway announcing tiny towns, and bird-pecked apple trees sit abandoned along the miles in between. In several places you can choose between traveling Route 66 as it was aligned in the 1930s, 1940s, or 1950s, and though the newest road is usually twice as fast, it also has half the character.

If there is a pastime here other than baseball it is the yard sale. In the middle of town, or the middle of nowhere, card tables full of used kitchenware and last year's Beanie Babies sit in front yards along the old road. Elsewhere, it seems these things last a day or two, but whether out of necessity or stubbornness, the Missouri yard sale is an all-summer event. Even if the wares come inside at night, it seems they are back in the same place the next day, and the day after that.

Shady Jack's Saloon

Nestled into a tree-lined hillside outside of Villa Ridge, Shady Jack's Saloon and Camp-Inn is a rare bird on the old road—a newcomer. While many Route 66 landmarks still thrive because of

CHAPTER 2

Missouri

Down the Old Wire Road

Route 66 cuts a long diagonal swath across southern Missouri. Just south of Springfield, an old steel bridge spans a creek full of oblivious carp.

"Shady Jack" Larrison is a new breed of entrepreneur along Route 66. Although he doesn't try to capitalize on his place's proximity to the old road, he routinely fills his 20-acre campground with travelers.

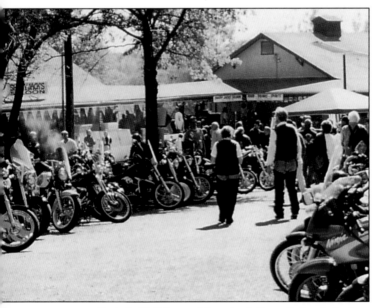

Shady Jack's Saloon and Camp-Inn is the perfect rest stop for large groups of motorcyclists.

their historic connection to the highway, "Shady Jack" Larrison opened his saloon with only a vague idea of its proximity to the route.

"I never really thought about it," he says, scratching his chin and pushing an errant ponytail back over his shoulder. "I mean, I always knew this was Route 66 down here, but never thought of it as a tourist thing."

Larrison, 57, has owned two things for most of his adult life: motorcycles and bars. And while his love affair with motorcycles began in 1960, he didn't get into the bar business until 15 years later, for an unlikely reason.

"Well, um," Larrison says with a sheepish grin, "I was a cop." Recruited into the St. Louis Police intelligence unit, Larrison worked deep undercover. In the late 1960s, riding around the city on his motorcycle, long hair blowing in the breeze, Larrison was often stopped by St. Louis police officers who had no idea who he was.

"Man, I've been stopped, beat up and strip-searched," he continues. "Luckily, I would have my gun and credentials on me. I worked mostly hookers and radical groups. Sometimes they would put me inside a company to investigate. There really were no boundaries to speak of." But while the work was interesting, after 10 years in the intelligence unit, Larrison grew tired of the dual lifestyle and constant danger.

"I got tired of getting shot at, or shooting at people, " he says, looking off into the hillside. "At first I would jump on my scoot after a shoot-out and be shaking so bad I could barely ride. Then it got to the point where it became second nature. I finally said to myself, 'This is nuts.'"

Working undercover, Larrison had spent many nights in St. Louis bars and had befriended both the owners and clientele. After leaving the force he quickly found work as a bartender. From there he moved into managing, and ultimately buying failing taverns, turning them around, and selling them at a profit. At one point he owned five different bars.

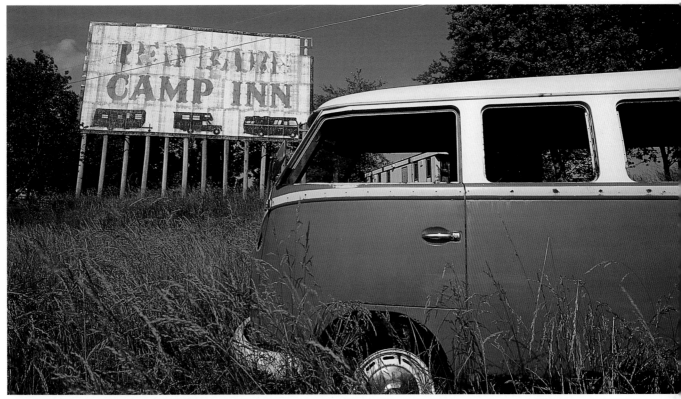

A fading sign recalls the days when Shady Jack's was the Red Barn Campground. The barn is still there, on its way to being converted into a clubhouse for visiting motorcyclists.

"I had college bars and sports bars and gay bars, but I never had a biker bar," he continues. "I had been looking for a spot for one for about two years. I was down in Daytona for Bike Week talking to a buddy about it, and he says, 'Man there's this place about 50 miles out of St. Louis—a campground.'"

The improbable biker compound he opened in 1997 has been an enormous success since its first day. Serving both the local population and biker demographic, Larrison struck on two hungry markets. Like other campgrounds, it has a full-service restaurant, bar, and swimming pool. And for the bikers there is a small shop offering Harley-Davidson merchandise and bike accessories, a leather repair service for sewing patches or mending jackets, and a tattoo studio across the parking lot in a house trailer.

"We took an old 4x8 piece of plywood and spray-painted 'Open Tomorrow' on it, and leaned it against a pole on a Thursday afternoon," he explains. "I went into town and got 40 cases of beer and loaded them into the back of my convertible. I sold it all the first night. Actually, I ran out and had to go to Wal-Mart for more." By Monday morning Shady Jack's had become the largest beer seller in Franklin County. But his overnight success was really a function of months of hard work.

The property was originally known as the Red Barn Campground, an RV park offshoot of the

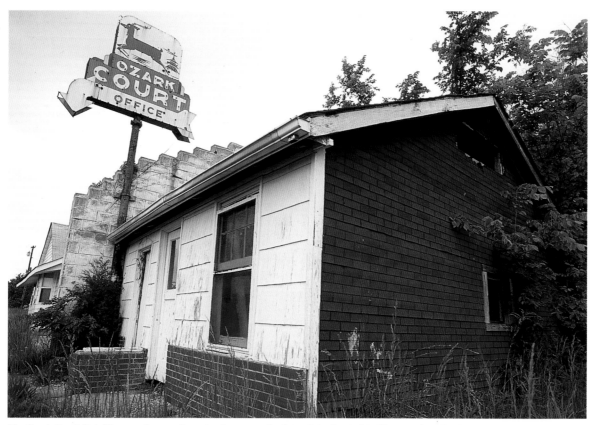

The Ozark Court Motel is one of many places to close once the interstate diverted traffic away from its door. Though the sign is no longer visible, we can only assume there is a vacancy.

Ramada Inn. Situated smack between I-44 and old Route 66, it drew a steady flow of campers and RVers before closing in 1987. The property soon became a Mecca for local teens and fly-dumpers, and before long was a wash of broken bottles and abandoned appliances.

"We hauled 27 dump loads of trash out of here. It was a pile of shit," Larrison explains. "The kids had just turned it into a big clubhouse, and other people came up here and dropped trash here too. You can imagine, being vacant for nine years, what it must have looked like.

"Actually, I didn't think we were going to make it. My brother thought I was nuts and tried to talk me out of it. But I knew this was something I

wanted to do. I really felt there was a need for it." Larrison's gut instinct was correct.

He's expanded his kitchen and is adding a meeting room off the pool area, a banquet hall upstairs, and is planning to renovate a barn into a clubhouse. He routinely fills the 20-acre campground with motorcycle and hot rod clubs, as well as veterans groups and the occasional Native American powwow. Though local bankers were skeptical when he first came to town, they've learned to respect his success and business savvy.

"When I first walked into the bank to buy this place, they looked at me like I had two heads. But after about a year and a half of going in there every three months with my profit and loss statements,

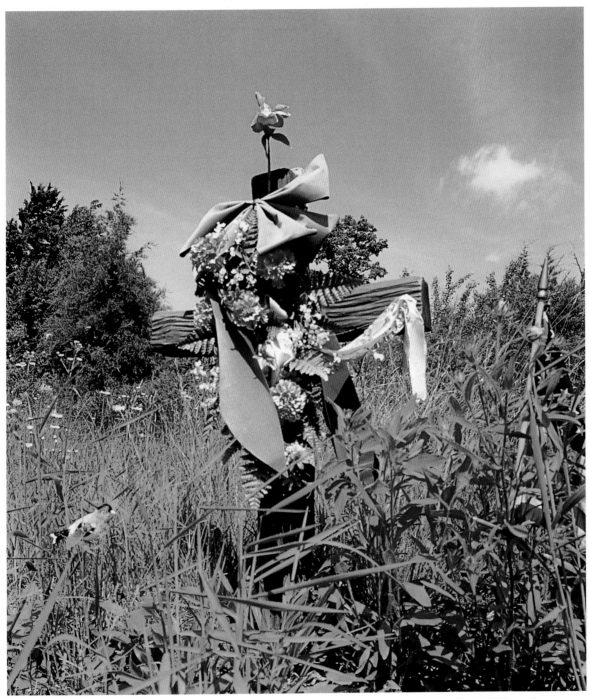

While we romanticize it today, in its infancy Route 66 was a very dangerous road, earning the nickname "Bloody 66" for obvious reasons. Even with speed limits and seat belts, the old road still claims its share of lives, as evidenced by this roadside cross outside Cuba.

Yard sales spring up everywhere along the road throughout southern Missouri. If the rust is any indication, this one in Carthage has a tough time moving inventory.

they started realizing I knew what I was doing. Hell, the banker comes out here every once in a while to visit."

Shady Jack navigates the turns through the kitchen and out behind the bar in long, fluid strides. Whether the product of years on a motorcycle or those spent dodging bullets, his cat-like moves mirror his easygoing manner.

His saloon has become different things to different people. To the locals it's a neighborhood tavern and restaurant. To the bikers it's a place to have club meetings and conventions—a place where they will be both respected and left alone. To the bank, it's a raucous reminder that men in suits are not the only ones with a flair for business. For

Route 66 travelers, especially those on motorcycles, it is a new and welcome oasis away from the urban grit of St. Louis. And for Jack Larrison, it is a dream come true.

He would like to open a chain of similar campgrounds throughout the country, and already has his eye on a location farther south in Missouri, in the Ozarks. But while he continues to plan for the future, Larrison remains pragmatic about the nature of business.

"I've been lucky," he says. "It takes money to run these joints, and you have to have money you're willing to lose. When I bought this place I had just gotten a divorce and didn't have the kind of money I needed to keep it going. I figured if I

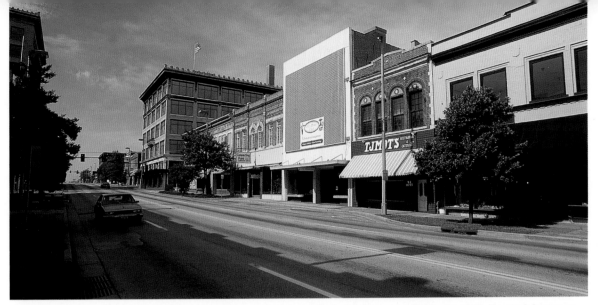

The last major town before entering Kansas, Joplin's main drag is mostly deserted on an early Saturday night. The steak houses on the edge of town are standing room only, however.

would try it and if it all collapsed, I'd just get on my scoot and leave. And I feel the same way today. One of these days I'm going to hand this place over to my son and jump on my scoot and go. There's always something else going on down the road."

Bloody 66

There are many things you'll see a lot of along this stretch of Route 66, but two seem to pop up with an eerie regularity: abandoned motels and roughly hewn handmade crosses.

The motels pop up every few miles, closer together than one would think the laws of supply and demand could accommodate. Perhaps that played a part in their demise, but a more obvious reason lies a few hundred yards away: Interstate 44. When it came through the old highway was relegated to use as an access road and the steady stream of travelers who once filled the rooms now sped by without even noticing the roadside inns.

The tradition of placing a decorated cross along the road where someone died is practiced nationally, but this stretch of the old road seems to have more than its fair share. Either folks here are mighty diligent about keeping them up, or "Bloody 66" has yet to live down its reputation.

They come in all shapes and sizes, but are typically around two feet tall and decorated with wildflowers. You'll notice them along the roadside in the middle of nowhere, tucked into the tall ditch grass or set out next to a mailbox. The newest ones are easy to discern, the vibrant purple and white flowers standing out against the green roadside. And while the sight of a new cross might cause you to ease up on that accelerator just a bit, realizing there are also two older ones next to it will bring you to a full stop.

As it continues west, Route 66 dips slowly south into the Ozark foothills. Signs for tourist attractions such as Meramec Caverns near Stanton, or the many wineries in the area dot the sides of the road. Running almost diagonally through Rolla, Lebanon, Springfield, and on through Joplin, the land begins to flatten back out. Lush hills recede into cornfields.

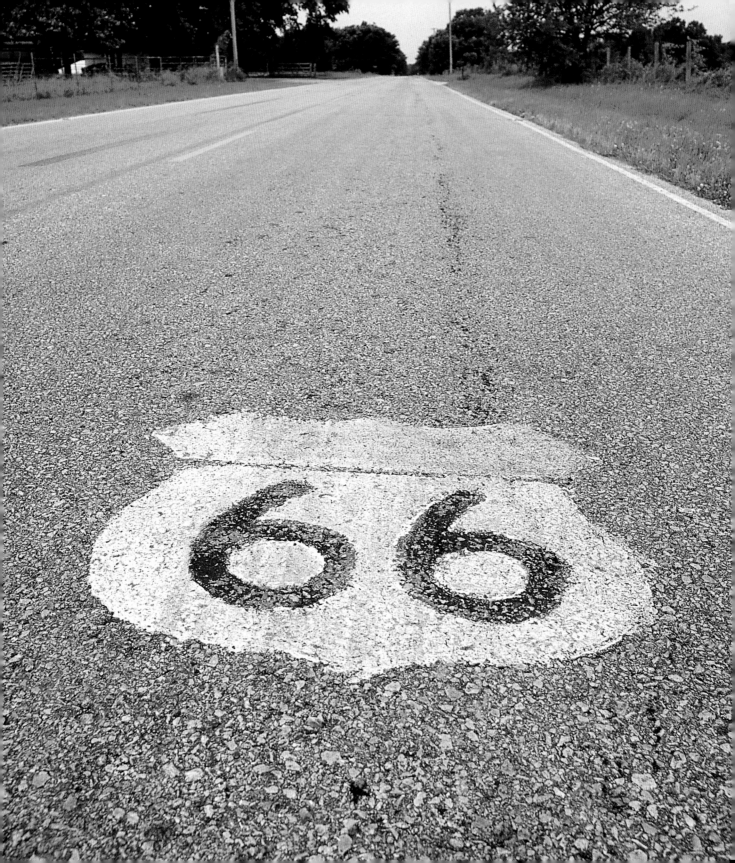

Crossing the border from Missouri into Kansas feels for all the world like sneaking in the back entrance of something. After bumping along the old road for a mile or so you climb a crumbling overpass and see what is left of the mining town of Galena.

There are still piles of mine waste, known as slag or chat, piled here and there a few hundred yards from the road. The town, like its country cousin in Illinois, was named for the type of ore that yielded tons of lead and a trickle of silver. But while its northern counterpart has evolved into a trendy tourist destination, Galena, Kansas, has faded quietly into oblivion. Driving through town early in the morning it's hard to tell which of the storefronts on Main Street are closed for the day, or closed for good.

Ahead in Riverton, the Eisler Brothers' General Store is the headquarters of all things Route 66 for the state of Kansas. Scott Nelson, its proprietor, runs the Kansas Route 66 Association, and the store's relaxed charm makes it a regular stop for those driving the road. It's a sunny but breezy morning when we pull into the Eislers' lot, and the place is absolutely buzzing. A group of German tourists traveling Route 66 on motorcycles from L.A. to Chicago is encamped for coffee and pastry. They're a motley bunch, all lawyers and junior vice-presidents, but their enthusiasm for Route 66 is innocent, almost childlike, and infectious.

Just west of Riverton, the Marsh Arch Bridge spans Brush Creek. Built in 1923, it's the newest and last survivor in a series of concrete arch bridges that were built within a few miles of one other. Once covered in graffiti, its fresh coat of white paint is still serviceable, although a few Route 66 travelers have written their names along the span.

There never was much of Route 66 in Kansas, just over 13 miles at best. While many towns grimaced as interstates bypassed them, Kansas bears the distinction of being the only state completely cut off by the closure of 66. Perhaps for that reason folks here seem to value their connection to Route 66 even more.

A handful of miles past Brush Creek is the last stop in Kansas, Baxter Springs. Though it started off as a wide-open frontier cow-town, it ultimately became famous as a tourist stop—presumably because of the healing qualities of the water from its namesake spring—long after the cattle drives ended.

CHAPTER 3

Kansas

The Few, The Proud

Golden Years

When Route 66 was finally paved all the way to Los Angeles, there were celebrations on both ends of

There isn't much of Route 66 in Kansas, but the few miles that pass through the Sunflower State are lovingly tended by a dedicated group of enthusiasts. This logo painted on the pavement just over the state line is just one example.

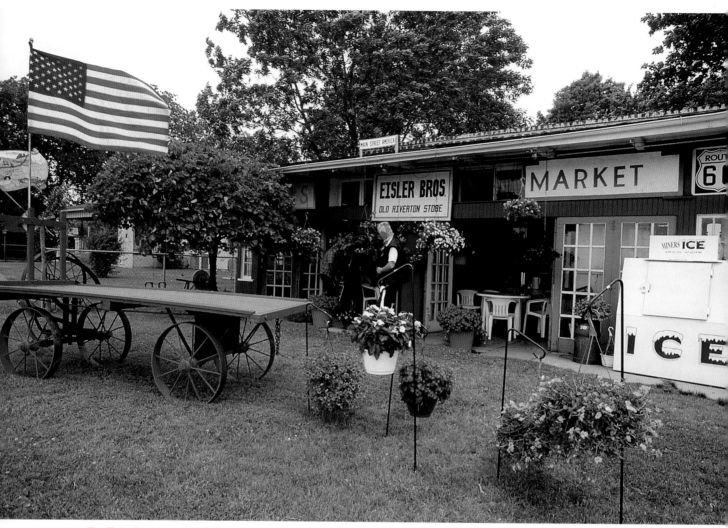

The Eisler Brothers' General Store is a popular stopping-off point for folks traveling the length of the old highway. They come from either direction, at all hours of the day, and are always met with a smile and a cup of good Kansas coffee.

the road. But in the height of the Depression, with a black cloud of dust choking the Southwest, the first people to travel the road were driven more often by desperation than a sense of adventure.

When John Steinbeck wrote *The Grapes of Wrath*, his stark portrait of an Oklahoma family's passage to California forever tinged Route 66 with a streak of sadness. Woody Guthrie's ballads and talking blues, while often tongue-in-cheek and optimistic overall, portrayed the fate of Okies along 66 as honestly. Between the two of them, they managed to imbue Route 66 with a tinge of loss that has forever become part of its myth and allure.

As the Great Depression wound down, Hitler's war machine wound up. When the United States

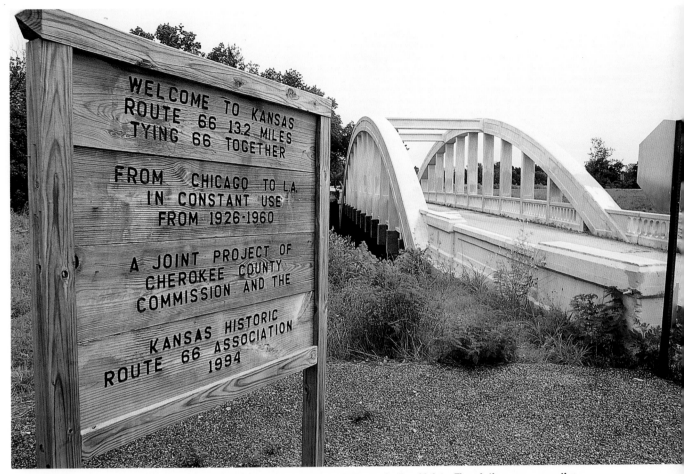

A simple sign pays tribute to the 13.2 miles of Route 66 that passed through Kansas in the old days. Though there were once three similar spans in the immediate area, the Marsh Arch Bridge is the last of its type left.

entered World War II, gasoline was rationed, new tires were hard to come by, and there were as many hitch-hikers as drivers on 66. But by war's end the economy had fully recovered from the Depression. Returning GIs were buying homes and cars and having families as fast as they could manufacture cribs and Oldsmobiles.

One of those returning servicemen was an aspiring singer-songwriter from Harrisburg, Pennsylvania, named Robert Troup Jr. On a driving trip to Los Angeles in the 1940s, his wife leaned over to him and whispered "get your kicks on Route 66". The phrase stuck with him. Five days after arriving in Los Angeles, Troup played the completed song to Nat King Cole. Neither Troup, nor Cole, nor Route 66 would ever be the same again.

While Cole had the biggest hit with the song, it has been recorded by every stripe of musical act, from the gutbucket blues of the early Rolling Stones to the techno-pop of Depeche Mode. Unwittingly, Troup composed an anthem that even after his death, continues to teach a nation about the joys of the "highway that's the best."

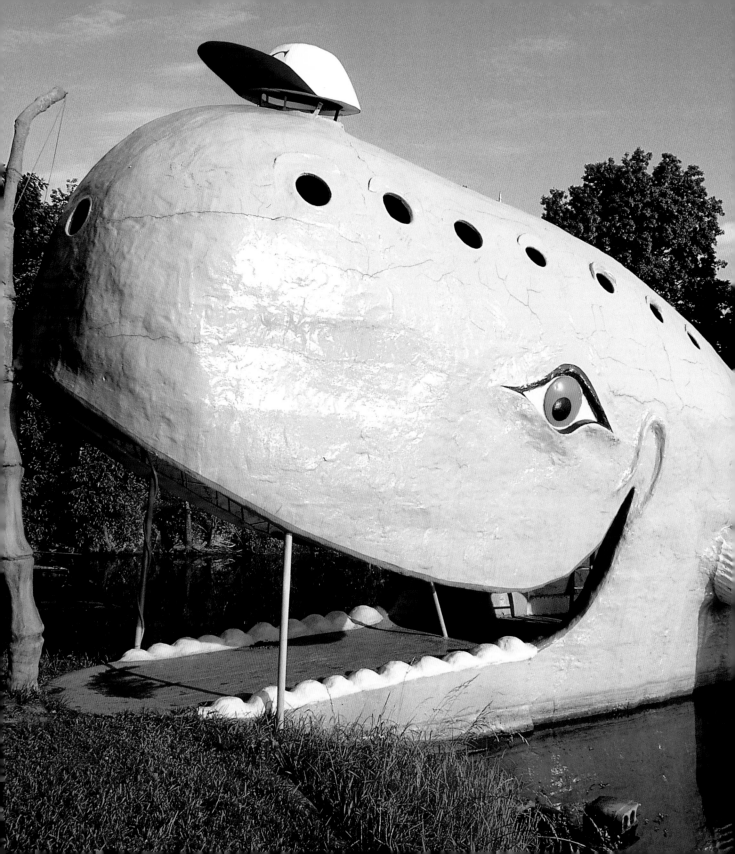

There is something disquieting about crossing the state line into Oklahoma. You notice it in your gut like a falling barometer at the first sight of road kill armadillo. This has always been wild land, whether in the possession of the Cherokee, Dust Bowl, or oil baron. And while it might be nothing more than the fine red clay soil blowing in the wind, there is still a taste of frontier in the air.

Unlike Kansas, there is a whole lot of Route 66 in Oklahoma, and a whole lot of Oklahoma in Route 66. The old road cuts a long, diagonal path across the state, dipping through Tulsa and Oklahoma City, on through Clinton and Elk City, before entering Texas just west of Texola.

It is here in the northeast corner of Oklahoma that history begins to come alive along Route 66. As you pass through Commerce, Miami, and Narcissa, you get a clearer sense of what the road was probably like in its glory days. Though these rural communities are obviously not all they once were, it seems that day-to-day life has remained fundamentally the same over the years.

When Route 66 was first paved in this part of the country, the roadbed was only nine feet wide,

including the concrete curbs. While the course of the highway changed a few years later, a few miles of these original sections are still drivable. Finding them, however, is a different matter. The maps and books we carry all place these sections somewhere between Miami and Afton. Upon reaching Afton without finding any sign of the original roadbed, we stop into the Route 66 Diner for a cup of coffee. Once sated with fresh pie and hot joe, we ask the waitress if she knows anyone around town familiar with the history of Route 66.

"What was you wantin' to know?" she asks. After explaining what we are doing, and what we are looking for, she sets the coffee pot down on our table and says with a smile, "Let me tell ya a little story."

Her father had worked on the crews that paved the road back in 1926. In a few minutes she gives us a thumbnail history and directions back to where some of the original alignment is still visible. We backtrack out of town, and turn off the state road. The road is rough but passable, quaint but unremarkable. We follow it along for a while, assuming we missed our turn-off again and are headed down just another Oklahoma gravel road. Then I see it.

A thin line of concrete begins to peek up through the clay and gravel in front of the passenger side tire. A little farther along, a matching strip of concrete pokes through on the driver's side. We stop the van and get out to investigate. Those two lines are actually the curbs from the original alignment we have been seeking.

Oklahoma

Barbecue for Breakfast

Once an oddball gift to an intended bride, the Blue Whale swimming hole attraction near Catoosa has received a fresh coat of paint and had its hat restored. While passé to the locals, travelers are often startled by the behemoth in the middle of nowhere.

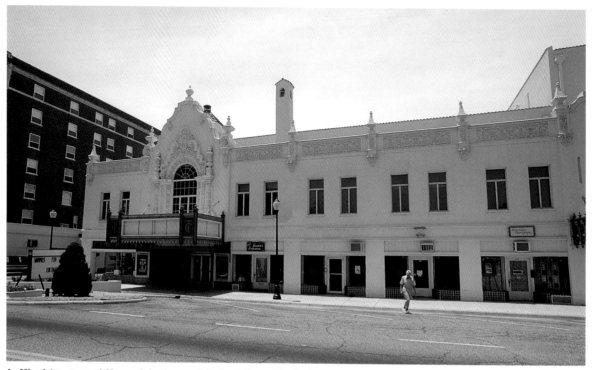

In Miami (pronounced My-am-uh in these parts), the Coleman Theater has gone through years of wavering business and states of repair. These days, though not all it once was, the old movie house is the pride of downtown.

A nine-foot-wide section—complete with curbs—of the original Route 66 roadbed near Afton. Legend has it that officials only paved it half as wide a necessary so they could go twice as far with the same money.

After a few hundred yards the full road emerges out of the gravel. Though pockmarked and bumpy, it is in remarkable shape given its age. We get out to take a closer look, keeping a close watch on the darkening western sky.

A series of tornadoes has just pummeled the area south and west of here a few days before, and both of us have seen enough PBS specials to know that although bad storms hit everywhere, they hit Oklahoma first and worst. The dark patch grows closer, as the temperature drops, and we barely manage to get the gear stowed before it hits the fan.

The wind blows hard enough to toss me against the side of the van, and the sky turns so black that headlights provide little relief. Rain pounds us in waves as we hurry back to the state highway. We speed south as fast as we can, and come out the other side of the front just south of Vinita.

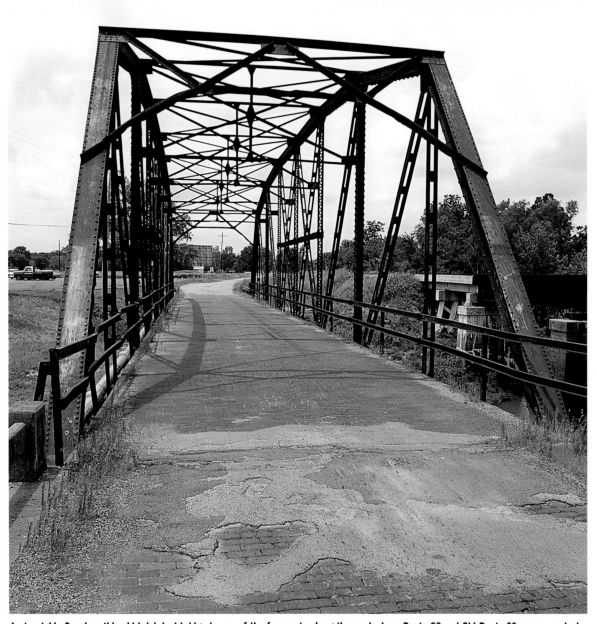

Just outside Sapulpa, this old brick bed bridge is one of the few spots along the road where Route 66 and Old Route 66 are so marked.

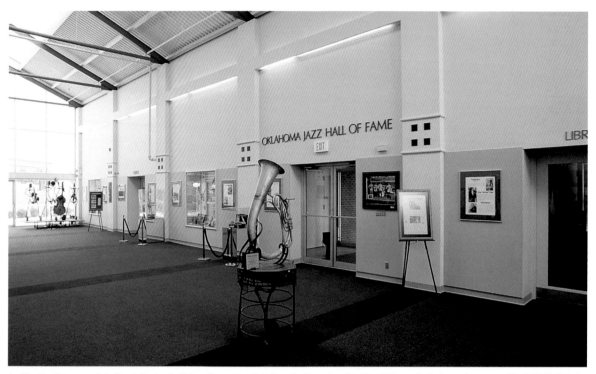

Inside the Greenwood Cultural Center in Tulsa, there are stunning displays showing the history of what was known as Black Wall Street, a thriving business section. Home to the Oklahoma Jazz Hall of Fame, the walls are lined with historic photographs and artwork.

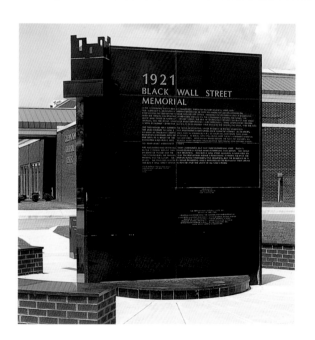

By the time we pass Catoosa it is a sunny afternoon with no hint of the storm that had just come through. Rolling into Tulsa to look for a motel, we spot a flag salesman near the side of the road. The flags are all Confederate, Nazi, or combinations of each.

Oklahoma has seen its share of good and bad over the years, and bears a grim distinction in the United States. The two greatest instances of Americans killing fellow Americans outside of the Civil War both happened here: when Timothy McVeigh parked

Outside the Greenwood Cultural Center, a somber marker bears witness to the Tulsa race riots of 1921. Whites stormed the neighborhood, killing more than 300, burning 36 square blocks, and herding more than 6,000 people into a nearby stadium. Recent investigations have discovered mass graves in the area that may push the number of dead even higher.

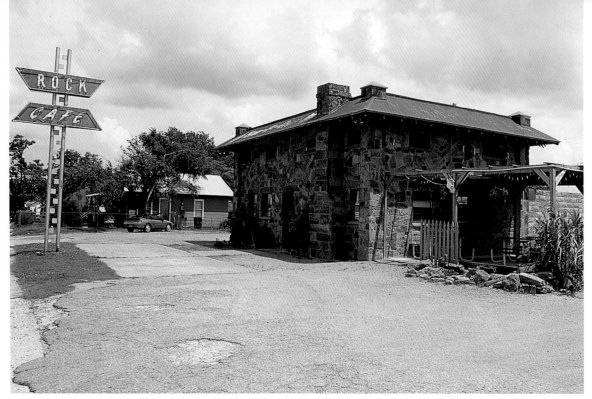

The Rock Café in Stroud was long a favorite stop for Route 66 travelers.

a rental truck outside the Murrah Federal Building in Oklahoma City in 1995, and when Ku Klux Klansmen burned 36 square blocks in the Greenwood district of Tulsa in 1921, killing more than 300 people.

There are two main museums dedicated to Route 66 in Oklahoma. The National Route 66 Museum in Elk City is modeled after a small town, replete with General Store, one-room schoolhouse, and towering Kachina statue. Spread across a few acres on the west edge of town, it's hard to miss. But for all its hokey theme park charm, the national museum rates a close second to its country cousin back in Clinton.

The Oklahoma Route 66 Museum is a neon and polished steel beauty. Visitors are given a portable cassette player and headphones, which provides a narrated tour they take at their own pace. Divided by decade, the exhibits range from the sober (an ancient flatbed Ford truck piled high with a Dustbowl family's possessions), to the psy-

chedelic (a Day-Glo-painted and black light-lit Volkswagen van from the 1960s). And while the museum is loaded to the rafters with interesting artifacts, across the street is a slice of Americana every bit as kitschy and compelling as Route 66.

Like a lot of things along the old road, the Best Western motel used to be something else. Back in the 1960s when it was the Gold Crown, the little motel in Clinton played host to a very famous visitor: Elvis Presley. He would usually arrive around midnight, on his way to or from Las Vegas, and spend most of the next day sleeping. Though he

Next Page
Long after an explosion ripped through the Murrah Federal Building in Oklahoma City, a statue of Christ was erected across the street. Back turned to the site of the tragedy, face in his hand, the inscription simply reads: "And Jesus Wept." Note the missing roof of the building in the background, yet to be replaced after being blown off in the bombing.

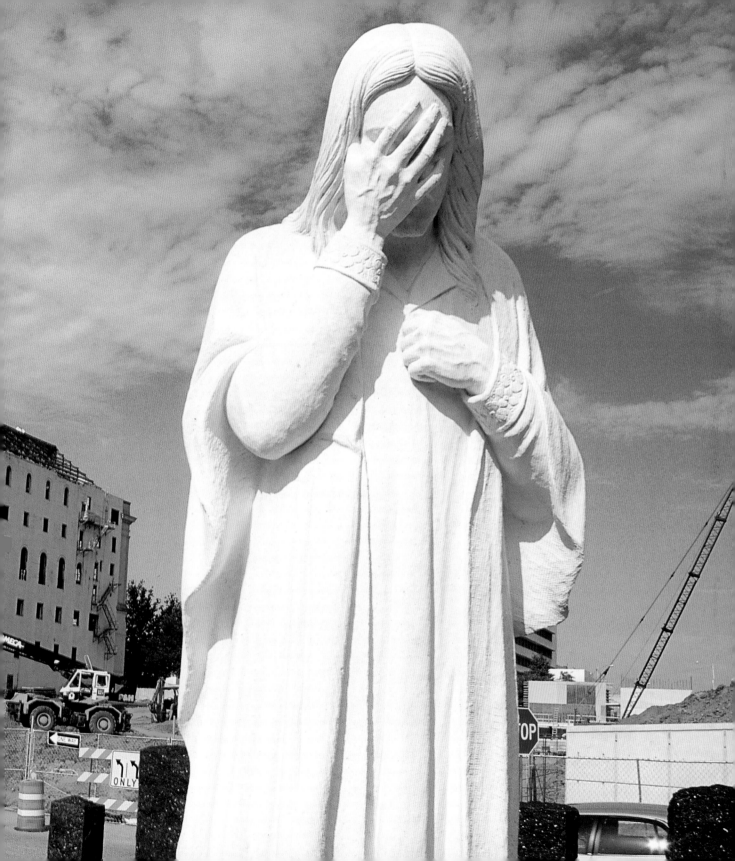

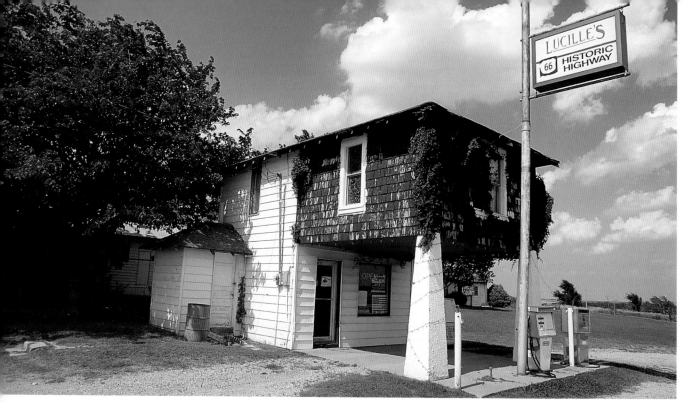

Lucille Hamon's gas station near Hydro was a mainstay along Route 66 for over 50 years. Although she passed away in 2000, pilgrims still stop to stare in her windows and reflect at the simple cross memorial to the "Mother of the Mother Road."

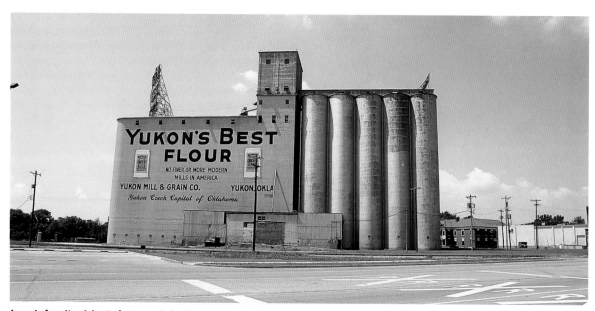

Long before its claim to fame was being the hometown of Garth Brooks, Yukon was, and still is, famous for its flour mill.

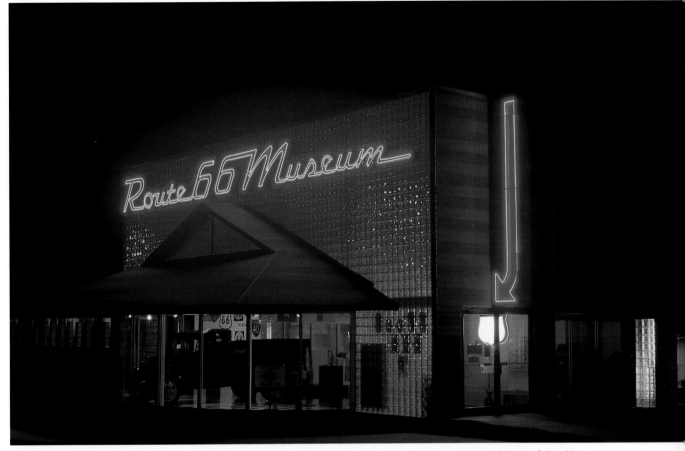

An old pickup sits silently on display at the Oklahoma Route 66 Museum in Clinton. Inside, visitors can view the history of the old road by decade, from the humble possessions of a Dust Bowl family to the psychedelic Volkswagen of latter-day refugees.

stayed there four times over the course of the years, the staff and townspeople only saw him once.

A housekeeper recognized Presley when she delivered his room service meal and spread the word through town. In short time a crowd gathered outside, waiting to get a peek at the entertainer. He eventually emerged to sign autographs and chat with the crowd, even pausing to play ball with some of the children in the parking lot. But soon, when his entourage had the bus loaded, he waved good-bye and drove off.

The room Presley stayed in is still there, carefully preserved with the same furniture and fixtures as the mid-1960s. It's available for a small premium above standard rates, a small price for a room fit for The King.

A Child of the Mother Road

Though he makes his home in Tennessee these days, songwriter Kevin Welch's ties to Oklahoma and Route 66 run deep. He grew up traveling the old highway with his family and eventually settled near it in Tulsa in 1962.

Like most young southern men with ambitions and a guitar, Welch left Tulsa and migrated to

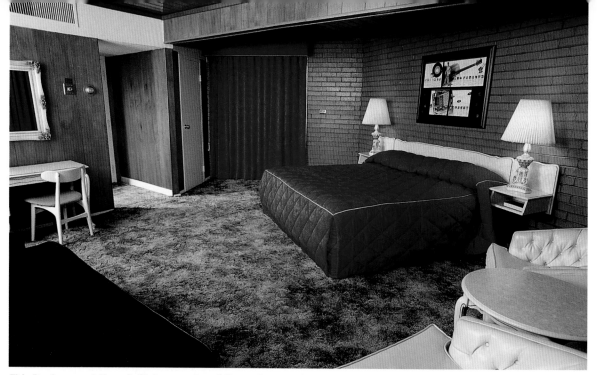

Elvis Presley passed through Clinton a number of times, always staying at the Golden Crown Motel on Route 66. Though today it is owned by the Best Western chain, Presley's room is preserved exactly as it was in the 1960s, when the singer last stayed there.

Nashville to pursue a music career. He found success as a songwriter, penning hits for country superstars such as Waylon Jennings, Roger Miller, and Ricky Skaggs. And all the while he was writing songs for others, Welch was building a potent portfolio of songs for himself.

In 1990, he released his major label debut, simply titled *Kevin Welch*. Its amalgam of punchy songwriting and twangy arrangements kept it from fitting easily into the playlists of rock or country radio, yet critics everywhere applauded Welch's undiluted style. One of the tracks contained was a paean to Route 66, simply titled, "The Mother Road." Though never released as a single, the song soon became something of an anthem for Route 66 enthusiasts and Americana buffs in general. And if there was any question about his sincerity or connection to the road, Welch explains it best in his own words:

"I was born in 1955 in Long Beach, California, where Dad was working as an aircraft mechanic. In those days, his job involved contract work with a field team of other mechanics, doing maintenance or modifications to any number of different type aircraft, usually for some branch of the military. Once a contract was fulfilled, the entire crew, including families, would pack up and move caravan style to the next job. This would typically mean driving from one side of the country to the other. Once we had arrived, everyone would set up housekeeping as best they could until the time came to move out again.

"Naturally, traveling as much as we did in those days involved many, many miles on old Route 66. I remember canvas bags of water hanging in front of the radiator for the long pulls across the desert. I learned to read from highway signs and billboards. The first real book of rules I learned was highway-driving etiquette, and I admired the truck drivers and their skills as much as my dad did. All of my earliest memories are of

the road: the gas stations (especially the red flying horse); the curio shops; fighting with my little brother in the back seat; or even, when I was real small, before David had arrived, riding on the floorboard of one of the pickup trucks we had for a while; or sleeping up behind the back seat below the rear window, a favorite spot.

"When we finally stopped moving, we settled just a few miles south of Route 66, close to the mighty intersection of I-40 and I-35. I will never forget my dad driving me down Sooner Road to where 66 crossed it, and telling me that if I went left, I could get to California, and if I went right, I could get to Chicago. I was 7 years old, and knowing that made me feel that I had the power and the freedom of any grown-up anywhere. It was nice to stop moving, but I felt so much more secure knowing how easy it would be to go back to the old ways. I lasted 10 years, leaving home to travel again at 17. Ever since, I have felt truly comfortable only when in motion.

"Back in those days, to my family, a road was a road, and it was judged based on its condition. So it's significant to me that even with those criteria, Route 66 still meant something more to us. It has always been a big deal to me, further back than my conscious mind remembers. I guess, as a child, I assumed the specialness of it was a secret only we were aware of. In later years, I was surprised and pleased that others felt the same way, particularly those who still live on the road. I was glad to learn they didn't take it for granted, and that they remembered its importance and history. Back in those days I thought of it as one very long, very thin city, and the ones who traveled it habitually as its residents. It was as much a hometown as anywhere else for us.

"Over the years I tried time and time again to express all this. I had dozens of bits and pieces of songs that never went anywhere. It was too big to say in a song. Too much of my own makeup was involved, and a song is such a tiny thing to jam a life into. Then one day my friend

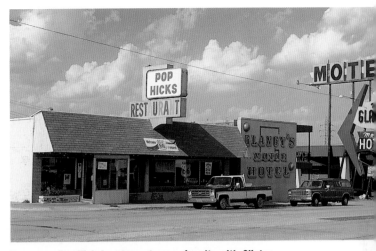

For years, Pop Hicks' restaurant was a favorite with Clinton locals and Route 66 travelers. Sadly, the business was destroyed after an electrical fire in 1999. There are no plans to rebuild.

Jonathan Lee Pickens stopped off at my house and told me about a newscast he had just seen. They said that the last stretch of the old road had finally been bypassed, out in Arizona, I think, or maybe New Mexico. It was a strange piece of news to hear. He had an idea for a song title, based on John Steinbeck's name for it, 'The Children of the Mother Road.' I was, I think, a little stunned by it all.

"That day or the next, Alan Rhody and I started a writing appointment, a common practice back then, as we were both staff writers for a large publishing company. The only thing on my mind was this story, and I told him about it. I dragged out all the notes I had kept for all those years and added them to the stack of words I already had. Alan wrote many of the key lines for the song, and soon we had finished 'Children of the Mother Road.' It still seemed, and still does, like only a tiny drop in the bucket. I always assumed I would write more songs to add to it, and really never have, unless you count all the many songs involving travel I've written since.

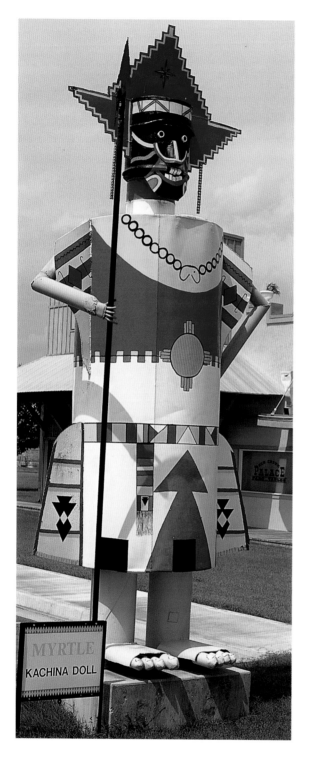

"In all the hypnotic rush of research and creation, my friend Jon Pickens, a tremendous songwriter, was completely left out of the process, and I have never stopped kicking my ass for that. I still am looking for a way to make that right with him, and someday I will.

"I've told some of this story before, but never in writing, and I just thought it best that you understood that I'm not playing around here when I sing that song. It doesn't come from anywhere but my own life, and to some extent, it *is* my life. They say the first seven years of a child's life are the formative ones, and I have reason to believe they may be right. It's a tender subject. I'm just one of millions whose lives have been affected by Route 66, and mine are small stories compared to some, but I thank you for the chance to tell some of them."

The Sword of Damocles

Things had more of an air of permanence about them in the 1950s. It was possible, almost expected, that you would find a good job and stay at it until you retired. That corner drug store had been there as long as you could remember and would be there long after you stopped concerning yourself with it. Before streamlined chain operations began slouching into rural communities and driving the locals out of business, you could count on things to last.

Legend has it that President Eisenhower was so impressed by Germany's autobahn, he felt the United States. should have a comparable system. While Ike might have liked a good drive as much as the next president, he had more pragmatic reasons for

The god Kachina Kaubat is revered in Native American culture and is a familiar sight along Route 66. This statue stands outside the National Route 66 Museum in Elk City.

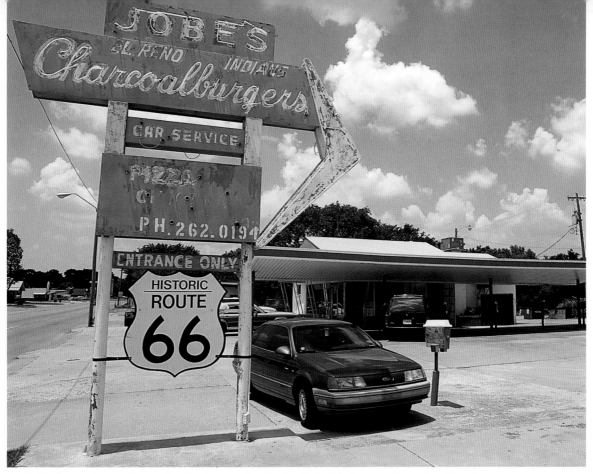

Jobe's Charburgers is one of hundreds of businesses who advertise their historic connection to the old road.

wanting to upgrade our highways. As a general he knew a quick system for moving troops and equipment between coasts was an essential part of national defense, and post-Korea, with the Cold War beginning to simmer, national defense wasn't far from people's minds. Although the superhighways were intended to move troops and equipment, an urban legend ultimately circulated that the government ordered one mile in five be straight, for use as emergency landing strips.

There will always be the folksingers among us who, regardless of what piece of progress and modernity confronts them, will feel the need to launch into a few bars about how good the old one was. Interstates weren't and aren't evil in and of themselves. In fact, the newer, faster roads did

much to increase the popularity of the driving vacation. But as Newton warned, "for every action, there is an equal and opposite reaction."

As the four-lane roads began skirting the edges of small towns all along Route 66, local businesses scrambled to attract customers. The savvier merchants quickly bought property near the exchanges and moved out to where they stood a chance of catching a few travelers' dollars. But for many small gas stations and restaurants, it meant a slow, agonizing death. While the long-haul truckers and vacationing families who once passed through their towns now sped happily by on the interstate, all along the old road stores closed, "for sale" signs went up, and the owners of the few that survived went home to an increasingly taller stack of unpaid bills.

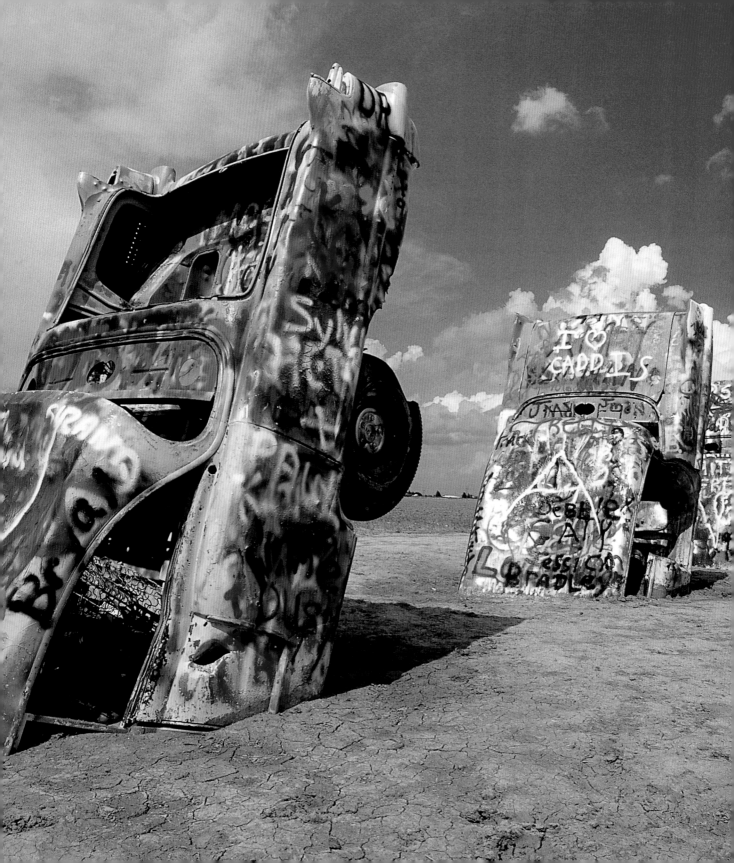

W e do. And for a couple of city boys who spend a good portion of their week in rush hour traffic, all this friendly waving and folks getting out of your way to let you pass feels a bit foreign. In the brown north country of Texas, the state measures less than 200 miles across. Here in the panhandle it's dusty, hot, and unforgiving, and if there is a redeeming quality about the landscape, it is only that it is not New Mexico or Arizona, exponentially wider and twice as hot.

The small brick service station outside Alanreed is overgrown but not crumbling. The hand-cut wood sign attached to the front reads "Super 66 Service Station." Peering inside, it looks as if someone simply turned the key and walked away, albeit many years before. A small desk still has paperwork on it; the nub of a pencil lies tossed to the side. In the opposite corner, a simple pallet bed still has its pillow and roughly sewn quilt, and next to it is a potbelly stove that has been cold for decades. The windows are covered with greasy dust, and on them fellow travelers have written

Local millionaire Stanley Marsh 3 conspired with an avant-garde art collective known as the Ant Farm to produce the classic bit of Americana: Cadillac Ranch. Though locals are either hot or cold on this and other Marsh projects, the Ranch is instantly recognizable by people from around the world.

their initials and the dates of their visits. We add ours between "Tom 4/10/99," and "Soon Jung Kwang 1998-10."

Once a thriving business, the old station is now an exhibit, on display for those traveling the living museum that Route 66 has become. Though its function has given way to form, it is in many ways a piece of public art—there for anyone to see and interpret through his or her own experiential filters. And while we tend to associate public art with statues and murals in exotic locations, this stretch of old Route 66 has several examples of outdoor art, from the serious to the comic. The next one is just outside the town of Groom.

It is billed as the largest cross in North America, and even from a mile out that claim seems reasonable. The religious behemoth is visible from both Route 66 and I-40 to the north, positioned that way to beam its message to locals and travelers alike. Though the cross itself is rather modern looking, at its base there are more traditional life-sized statues of Christ at the Stations of the Cross. Though many people only see it from the interstate at 70 miles per hour, the lot is just as often full of tour busses and traveling families who can't pass up the curiosity.

Though the cross and its underlying message are an integral part of the way American culture has shaped itself over the years, a few clicks farther up the road is something just as American, without the serious undertones.

CHAPTER 5

Texas

Drive Friendly

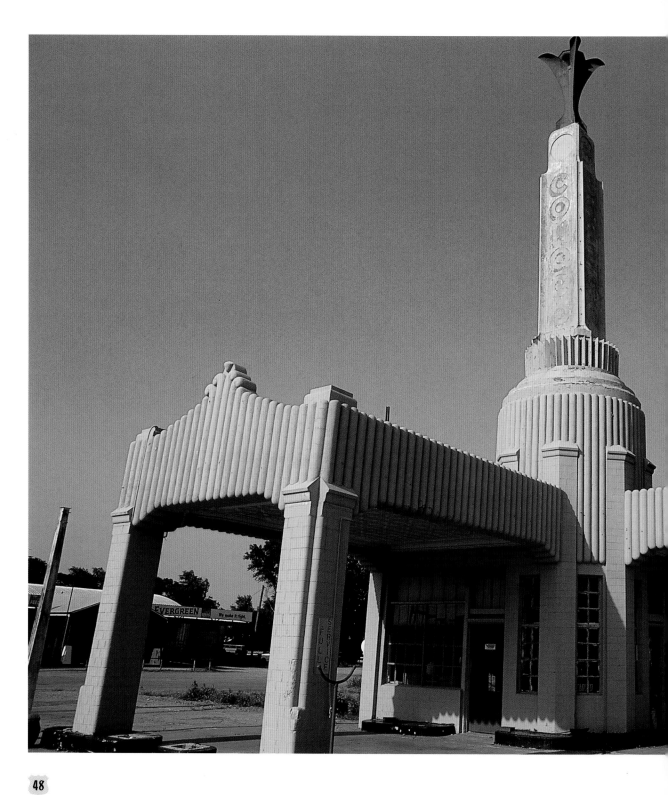

The leaning water tower outside Britten might have been inspired by a certain structure in Pisa, Italy, but its mission is good old-fashioned American huckstering. Designed to attract both attention and visitors to Britten, travelers have indeed done double takes as they passed into town. Whether they actually stopped and patronized any of the local merchants as town fathers intended is unclear, but the tower remains one of those classic, funky treasures along Route 66.

The leaning tower and giant cross are fine examples of unintentional public art. At the core, they are advertisements, selling religion and civic pride with equal fervor. Whatever artistic merit they have is secondary, noted more by latter-day observers and critics than through the intentions of the people who erected them. But a few miles up the road there is art to be found that is both intentional and serious-minded.

The area surrounding Amarillo is one of the richest helium fields in the world. While a lot of Texas fortunes were built on oil, up here they're built on gas. Stanley Marsh 3 (as opposed to the more traditional III) is a helium man, prankster, and a visionary with a passion for art.

In certain circles you can't swing a cat without hitting a person willing to explain *ad infinatum* the artistic relevance of Marsh's Cadillac Ranch. But mostly what you are struck by as you trek up the compacted dirt road that leads to it is the realization that someone has stuck a bunch of cars into the ground nose first.

Yet no matter how haphazard it looks, Marsh's world-renowned installation on the western edge of Amarillo has broader themes behind it. The 10 Cadillacs, from a 1949 Coupe to a 1963 sedan, are buried in a simple line at the same angle as the Pyramid of Cheops in Egypt. When the Ranch was

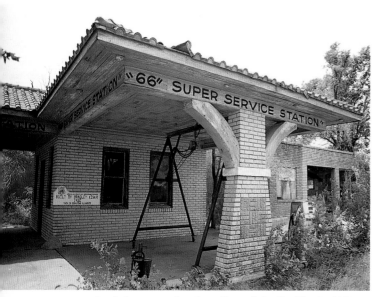

In what was once downtown Alanreed, Bradley Kiser's old Super 66 Service Station is now a landmark for Route 66 travelers, who leave their initials written on the dusty windows after viewing the period interior.

A few miles south of town, what appears to be a broken statue sits unnoticed by travelers whizzing by on the nearby interstate. But "them legs" as it was called by a local merchant from whom we asked directions is in reality titled *Ozymandias*, a serious spot of art inspired by the great Romantic poet Percy Bysshe Shelley.

Written in 1818, *Ozymandias* is one of Shelley's most-beloved sonnets. The title comes from the Greek name for Ramses II, the Pharaoh that Moses and the Israelites fled long before the birth of Christ. The poem tells the story of a traveler who encounters a crumbling statue of the Pharaoh while exploring the Egyptian desert:

> *I met a traveler from an antique land*
> *Who said: "Two vast and trunkless legs of stone*
> *stand in the desert."*

Some 170 years later, Marsh used Shelley's imagery as the basis for the piece, which is literally two legs on a pedestal. Like Cadillac Ranch, locals either scratch their heads in disbelief or greet it with open hostility. And every few years, when Marsh announces his intentions for another project, a good portion of Amarillo rolls its eyes with a "here we go again" sigh.

But many of his neighbors don't realize that Marsh is a subversive genius. Even if they are saying how much they hate one of his pieces, he has them talking about art. In a city with a higher incidence of bar fights than ballet performances, that's no small feat.

The Castle on Sixth Avenue

As Route 66 snakes along Sixth Avenue in Amarillo, it passes through a burgeoning antique district. Old storefronts of every stripe have been converted into consignment shops filled with the good, the bad, and the overpriced. And in the middle of it all, an interesting looking old building with a historical marker in front has a thousand

originally installed in 1974, the outskirts of Amarillo were still miles away. But over the years, development crept west. By early 1997, several mega-stores and (ironically) a Cadillac dealership had become neighbors. Marsh was not pleased with his work's new backdrop. That August he brought in heavy equipment and moved the whole installation two miles down the road, telling local reporters that the cars had wanted to enter a square dance contest.

Over the years it has become a tradition for locals and tourists alike to leave their names and words of wisdom inscribed somewhere on the cars, making it a truly interactive art exhibit. It is rumored Marsh stops by periodically and watches people's reactions, often chatting with them without ever revealing his connection to the work. But while the Cadillac Ranch leans toward the whimsical, another bit of Marsh's handiwork is more rooted in serious literature.

stories to tell, of presidents and pop stars, travelers and Texans alike.

Before air conditioning and the $9.99 electric fan, escaping the brutal Texas heat was a welcome treat. The Amarillo Natatorium opened in July 1922 as a lavish open-air swimming pool. It was covered a year later to provide year-round use. In 1926 it was sold, and a floor was built across the drained pool, converting it into a dance hall. Patrons paid a nickel per dance, and the floor was cleared after each song.

In 1935, a restaurant was added to the north face of the building, providing an entrance from Route 66, and business boomed. The ballroom soon became a regular venue for MCA orchestras passing through Amarillo. In its prime the Nat hosted Duke Ellington, Bob Wills and his Texas Playboys, Tommy and Jimmy Dorsey, Guy Lombardo, and many others. It was also a favorite spot for private and political functions.

"It was the biggest nightclub between Dallas and Denver," says owner Pete Elkins. Though they still operate the old ballroom as an antique mall, Elkins and his business partner, Mike Baker, are determined to revive the Nat's proud history as a venue for live music. And with more than 20,000 square feet of inventory, that's not an easy task. Every night they have music, Elkins must clear the floor of all the antique displays to make room for the crowds.

"We have a whole crew that comes in," Elkins explains in an easy drawl. "We move everything out of the way and cover it all up to make room for the dancers." And while that seems like a Herculean task, Elkins shrugs it off with a football analogy.

"Shoot, man," he laughs. "They do the same thing every year at the Super Bowl. They set up a whole sound stage and everything in 15 minutes. It ain't that bad."

Over the years the Nat has played host to thousands of bands and even more patrons. Back

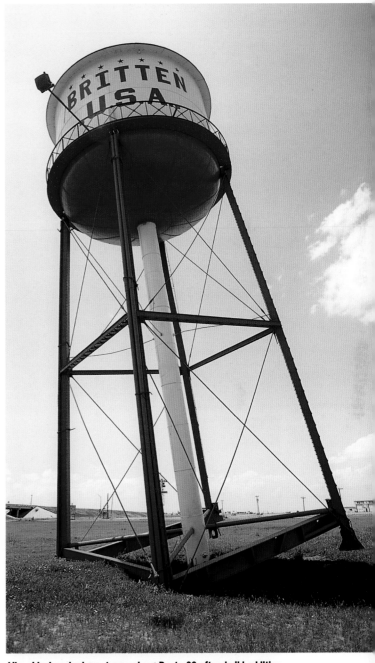

Like sideshow barkers, towns along Route 66 often build oddities hoping travelers would be intrigued enough to investigate, and perhaps stay long enough to drop a few dollars. Outside Britten, the leaning water tower produces more smiles than dollars.

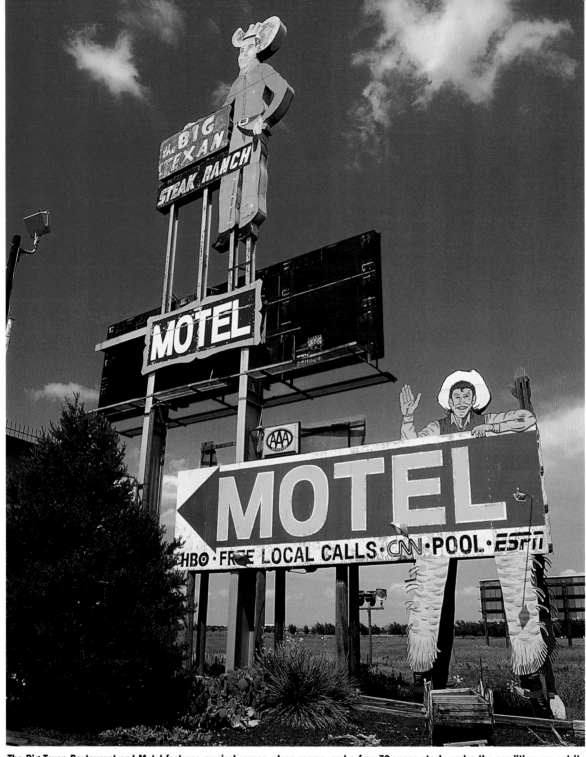

The Big Texan Restaurant and Motel features musical revues, clean rooms, and a free 72-ounce steak, under the condition you eat it and the accompanying side dishes within an hour. Few attempt it, and fewer leave without paying.

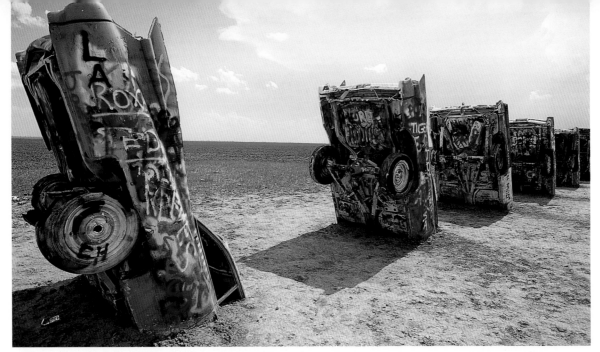

When an actual Cadillac dealership sprung up in the background of his artwork, Stanley Marsh dug up the Ranch and moved it a few miles father down the road to its current home west of Amarillo.

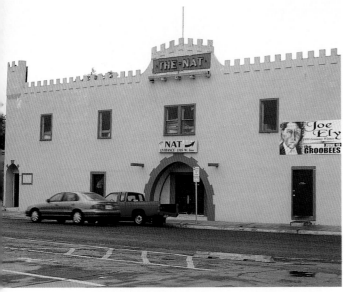

The Amarillo Natatorium has served as a swimming pool, a dance hall, and antique mall over the years. These days, owners continue to stock antiques, with hopes of returning the sprawling building to its roots as a dance hall.

in the 1940s it was a favorite haunt of local servicemen stationed nearby. And while there was always the occasional fight or trouble, Elkins only recalls one instance when a performer was hauled off the stage and arrested.

"Well it was back in the '50s. You have to remember now, this was a pretty redneck part of the country back then," Elkins says. "Little Richard was playing here, and I guess they said he was a little intoxicated or something. But anyway he undid a button on his shirt or something and they came and took him away."

For the record, Little Richard bothered a lot more people than just the Amarillo police back then. He raised eyebrows across the country with his sexually charged music and androgynous look, and his propensity for dropping his trousers in the middle of a performance didn't endear him to many local constabularies. Like The Doors a decade later, there were often police officers in the audience wherever he played, waiting for him to cross the line.

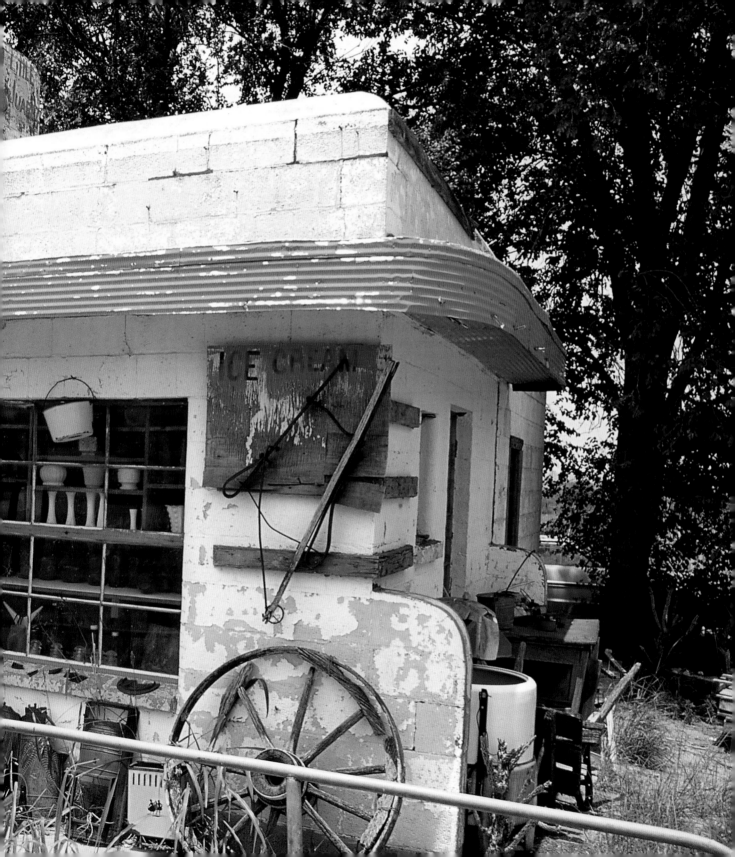

Previous Page
On the deserted Main Street of Glen Rio, an old store still has odds and ends on the shelf. Now overgrown and forgotten, Glen Rio is an eerie metaphor for the ruin visited on many towns along the old road.

While Elkins features live music as much as he can, he's also set up a small broadcasting museum in a corner of the old ballroom, and a makeshift diorama saluting the Big Band era on the stage. And while he is keenly aware of the historic value of the building—it's on both the national and state register of historic deeds—there are plenty of visitors coming through that remind him.

"We get folks coming in all the time who tell me they used to dance here when they were younger," he continues. "Either that or this is the place they met their wives or husbands or something like that." In addition, the sprawling complex is something of a time capsule. Elkins says he is forever turning up old ticket stubs and photos from under a carpet or behind a wall.

Wipe the windows, check the oil, dollar gas. A long-closed Glen Rio gas station still has cars waiting out front for service that will never come.

Although he doesn't stock much, if anything, in the way of Route 66 souvenirs, Elkins says he gets a steady stream of people in his shop who are traveling the old road. "The local Route 66 association has done a lot to help turn this area around," he explains. "We have all sorts of events, and book signings and so forth."

Walking along the creaky wooden floors in the old swimming hole *cum* dance hall, it's easy to imagine the place full of flirting couples and sweating musicians. Like so many places along the old road, the Nat is full of ghosts. We take our leave of Amarillo, on our way to a place where the ghosts outnumber the living.

Glen Rio's Relics

West of Amarillo it is flat, flatter, flattest. Old Route 66, now a bumpy access road, runs parallel with I-40 for a good spell, so there is little difference between driving it and the interstate. Rolling ever westward through Vega and Adrian, you draw ever closer to a chilling example of what happened to hundreds of towns when traffic was routed off of Route 66 and onto the interstate.

There never was much of Glen Rio, which shows up on maps in New Mexico as often as it does Texas. There is a house at either end of town with laundry on the line, and pickup trucks too new to be abandoned in their driveways. But what lies between is every bit the ghost town it's advertised to be.

Even in the blazing sun of a Texas summer, Glen Rio is an unsettling place. Things are uncertain and often contradictory here. Though dead as a town can be, the place buzzes with life. Gophers scurry across your boots in the overgrown yards, while grasshoppers thrum all around, almost drowning out the interstate, and a pack of stray dogs arrogantly roams the main drag.

Rusting cars sit in front of an overgrown gas station, as if waiting for service. An occasional car passes through headed west, but invariably returns

Once a bustling stop off on the New Mexico border, the First Motel in Texas/Last Motel in Texas is a rotting hulk. Though much of the building has been stripped of usable items, the combination motel, gas station, and diner's banking and business records lie among the ruins for all to see.

a few minutes later, afraid to try the primitive road leading west out of town. It is both a symbolic and literal end of the road. None but the brave or local rancher passes through Glen Rio without hurrying quickly back from whence they came.

Just down the street is the shell of what was once Glen Rio's finest business. Depending which way you are headed, the sign in front reads either Last Motel in Texas, or First Motel in Texas. Aside from people traveling Route 66, its only regular visitor these days seems to be the postal carrier, servicing the small cluster of mailboxes mounted on a pole in the building's gravel turnout.

The ruins of the old business are scattered with history. Leaning down to pick up a stack of papers, something larger than an insect darts away a few feet from my hand. Leafing through the tattered papers I realize they are the old bank records from the motel. After a little scanning and some quick math, it's obvious this was an incredibly successful place, doing a five-figure business more

than 40 years ago, and that makes the crumbling skeleton it has become even more poignant.

If nowhere else along the old road, here in Glen Rio you feel the full effect of the tragedy that must have visited thousands of other businesses when Route 66 was decommissioned. The hum of the interstate, hardly noticed before, seems louder and oddly menacing as I walk through the abandoned motel rooms and restaurant.

In front of a room near the motel office, a broken metal chair sits beside the gaping hole where a door used to be. I sit down carefully, lean back and light a cigarette, listening to the 18-wheelers screaming from the interstate a mile or so away.

Glen Rio is an odd portal in many ways. Somewhere on that short strip of blacktop you pass from Texas into New Mexico, from Central to Mountain time and from the bones of an old town into the great wide open. Pictures taken and equipment repacked, we ease the van out of the parking lot of The Last Motel in Texas in dead silence.

The road west out of Glen Rio looks questionable. Our guidebooks say it is drivable, "weather permitting," and since it's a glorious summer afternoon it seems worth a shot. The blacktop soon gives way to primitive gravel, and we descend in earnest into the *Llano estacado*, the staked plain, so named when the first settlers who passed through pounded stakes into the ground to mark a trail.

I-40 falls farther away to the north and the countryside is still, except for distant chattering of crows and mooing cattle. A huge bird—a hawk or golden eagle perhaps—rises out of an overgrown ditch as we approach. The rolling hills and crested buttes seem to announce we have officially left Texas and entered the Southwest. It's almost 30 miles into the tiny town of San Jon, where after a stop for ice and gas we continue west into Tucumcari.

Anyone who traveled Route 66 in its glory days will certainly remember the "Tucumcari Tonight" signs that started popping up along the road back in Texas. Once boasting more than

CHAPTER 6

New Mexico

Uranium Below— Cobalt Above

2,000 motels rooms along its main drag, the sleepy first stop on the way through New Mexico retains all its charms, if fewer rooms.

The Blue Swallow Motel is a certifiable piece of history along this section of Route 66. Run for years by the venerable Lillian Redman, it is now operated by Dale and Hilda Bakke, who have put much effort into preserving the motel's historical features, especially its trademark neon.

Stepping inside one of the Blue Swallow's rooms is like turning back the clock. A huge vintage air conditioner, from the days when the motel proudly offered "100% Refrigerated Air", lines one wall. The bathroom has a window that opens wide, allowing a cooling cross-breeze, and next to each room is an accompanying garage to keep one's car out of the sun on hot days. Then there are the telephones.

The vintage Western Electric models are huge, black and use a dial instead of a keypad. The receivers seem to weigh five pounds each, and although they look like they have been here for years, they are actually new additions to the Blue Swallow. Back in Route 66's heyday, there were no phones in the rooms. The Bakkes purchased them from a restoration house in Chicago and installed them with the help of a grant from U.S. West. (Fear not, laptop luggers: There is an extra jack in the wall for you to connect your modem.)

Between Tucumcari and Albuquerque a succession of failed or failing little towns dot the

Long ago, Tucumcari boasted 2,000 motel rooms. That number has dropped significantly, but there are still plenty of places to stay. The Blue Swallow is a Route 66 classic and is being slowly restored by its new owners.

These days San Jon is little more than a place to jump back on to Interstate 40. But years ago this old mill hummed with workers from the surrounding area.

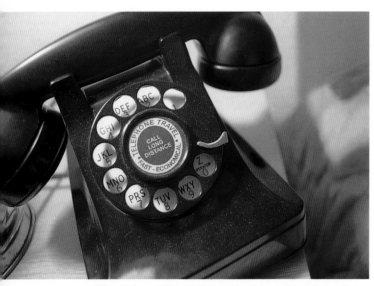

When Dale and Hilda Bakke decided to install telephones in the rooms, they sought out the real deal. These vintage models were purchased and installed through a grant program offered by a telephone utility.

scrub brush and scattered cattle. On through Montoya, Cuervo, and Santa Rosa, the sky shines in a brilliant blue, a sharp contrast to the ruddy soil beneath.

Jogging north on an older alignment of Route 66, Santa Fe's art colony buzzes with tourists. Galleries dot the streets like Starbucks franchises. Almost everyone here is an artist of some stripe, whether painting or sculpting or crafting new ways to separate tourists from their *dinero*. Keenly aware of its history, the town allows little new construction that does not resemble adobe in some way. Even the downtown parking garage looks like an ancient pueblo.

Weird Science

Driving east on Gibson Avenue, on the southern edge of Albuquerque, you are greeted by a huge billboard welcoming you to "America's Nuclear Weapons Colony." It is an odd contrast,

seeing something so many people lived in fear of all their lives so openly embraced, but nuclear weapons and the science surrounding them have always been prone to contradiction. Here, in a top-secret facility inside Kirtland Air Force Base, a cadre of physicists and thin-lipped government types have spent almost 60 years designing the weapons that fueled the Cold War.

At the end of World War II, a small group of researchers, cryptically known as Z Division, set up shop on the site. Four years later, the Sandia Corporation, a subsidiary of Western Electric, took over operations of the facility, and began expanding the labs. As America put its Cold War machine into gear in the 1950s, the facilities grew exponentially, and the lid clamped down activities at Sandia.

Over the years, scientists developed many refinements to both guidance and delivery systems for weapons, and like a true nuclear reaction, their research often fed upon itself, spinning the labs into new areas of study. For example, monitoring test explosions led scientists to develop the Vela satellite, used to detect nuclear tests from space. And Sandia's famed "Z machine," the most powerful X-ray generator in the world, though used primarily to test the effects of a nuclear explosion on different materials, is also able to mimic the temperature on the sun in experiments on black holes. But Sandia's crowning achievements have always been in the business of bombs, and though security remains tight at the labs, across the base there is a public face to the lab's private labors.

The National Atomic Museum elicits an odd combination of pride, shame, and fear. Outside the former ordnance repair shop a collection of missiles and aircraft used to deliver nuclear weapons sit gutted, yet menacing. Inside, though there are thoughtful exhibits on miniature robotics, the life of Marie Curie, and the benefits of nuclear medicine, most of what is on display to the public are tools of mass destruction.

The next-to-last picture show. Even in the age of easily rented home videos, the Odeon Theater in downtown Tucumcari is still the best show in town.

A pair of ship-launched missiles mark the entrance to the National Atomic Museum at Kirtland Air Force Base. A few miles away, the scientists at the Sandia National Laboratories are still designing nuclear weapons.

Most people are familiar with the "Fat Man" and "Little Boy" weapons used in Japan, but the museum holds sundry other devices most of us didn't know existed. There are nuclear mines, meant to be placed in enemy harbors, nuclear shells designed to be fired from conventional artillery, a bazooka-launched warhead, even a backpack-sized bomb designed to be carried into action by a paratrooper (though there is no explanation of how the paratrooper is supposed to get away from the blast after deploying the weapon).

The museum is a testament to both the scientific brilliance and childish naiveté of American officials during the Cold War. They were visionary enough to build a bomb you can carry on your back, but blind to the fact that even using it could trigger a retaliatory firestorm that would destroy the planet. Today, even as the superpowers back away from proliferation, Sandia personnel remain saddled with the dual-mindedness of their predecessors.

In 1998 alone, Sandia delivered more than 20,000 components to the Department of Energy for application in nuclear weapons. Yet at the same time, they were developing safer and more effective ways to monitor existing stockpiles, and dismantle outdated platforms. Accepting cradle-to-grave responsibility for the weapons they design, Sandia scientists have unwittingly provided themselves the ultimate in job security. And as the political face of the world changes, researchers have scurried to meet new challenges.

As individual acts of terrorism become more of a threat than an all-out nuclear war, scientists have developed hand-held electronic "sniffers" that can detect even minute traces of explosives (or illegal drugs) on travelers. They have built virtual reality simulators that allow emergency response teams to train for a nerve gas attack in heavily populated areas. And in the wake of the recent string of high school shootings, researchers are developing sophisticated detection and surveillance systems schools can install to prevent further tragedies.

So in many ways, Sandia is at the forefront of pure research, but remains grounded in the business of death. It is first and foremost a national security laboratory, existing solely to apply scientific and engineering principles to repel foreign or domestic threats. And if by some chance the geopolitical face of the world reverts back to what it once was, Sandia will be ready.

Not far from the National Atomic Museum, hidden deep in the Manzano Mountains, is an underground vault where more than 98 percent of the world's supply of weapons-grade plutonium was once stored. Though it is uncertain how much, if anything, the facility holds today, odds are there is still a good supply of bomb-making supplies somewhere near Sandia. Just in case.

The Old West

West of Albuquerque the old road dips in and out of several Native American reservations, and

even from Interstate 40 pueblos are sometimes visible. In the old uranium-mining town of Grants you can get a hearty breakfast with regional options (hash browns or beans, toast or tortilla) before continuing west. Just outside of Thoreau you cross the Continental Divide (rainfall east of it drains into the Atlantic; west of it into the Pacific), and a few miles farther up the road is Gallup, home to the El Rancho Hotel. Over the years it's done double duty, acting both as a home for movie stars shooting westerns in the surrounding desert, and as a location itself. Its rough-hewn log interior has often doubled for an Old West hotel or saloon.

And it is into the Old West for sure. It is unseasonably cold, no more than 40 degrees at first light, but the Arizona border is a few miles away, where the temperature will surely rise. We are in the desert somewhere between Manuelito and the Chief Yellowhorse Trading Post when I spot something by the side of the road up ahead.

At first it looks like a big bag of trash someone had tossed away carelessly, but as we grow closer I notice it's a vibrant purple, not drab green. And by the time I realize it is an elderly woman, she already has her arm out, thumb extended.

It is still freezing, and she wears only a thin coat over her dress. A frail Navajo named Betty, she is trying to get to her son's home on the reservation a few miles across the border. We crank up the heat and give her water as she tells us her story in broken English.

"My husband . . . he's a Mexican up in Gallup," she explains. "Last night he tell me, 'I don't want you anymore—go.'" Though she said she had nowhere to go, he insisted she leave. "'Walk,' he said." And so she did. Gallup is a good 25 miles behind us, and a little quick multiplication tells us she must have been walking all night in the desert cold. We cross into Arizona in an uncomfortable silence, Betty holding her bottle of water and gazing out the back window.

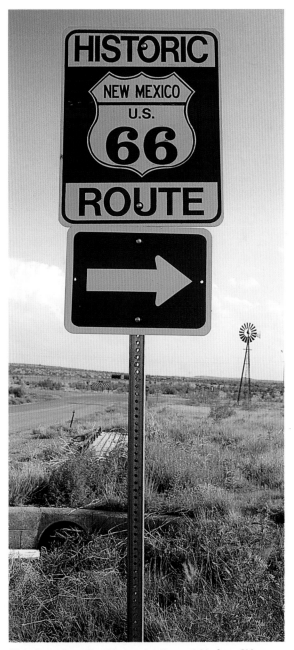

Historic markers like this one dot the roadside from Chicago to Los Angeles. Though you'll still need some good maps to follow it all the way, the familiar brown-and-white signs offer a quick trip back in time for folks who would otherwise stick to the interstates.

Modeled after a similar structure in Paris, the Lorretto Chapel in downtown Santa Fe is one of the many churches and missions that date back to the nineteenth century.

As we approach the exit for Chambers she begins gesturing and saying something about "sonny boy." Though we aren't sure exactly what she means, we figure it be best to exit. She directs us to the nearest gas station and points across a long field to a row of cinder block homes a half-mile away.

"My sonny boy—he live here," she says with a grin. She jumps out of the van and walks across the tarmac of the gas station. I watch in the rearview mirror as she steps down the embankment next to the road and starts across the field.

Gear stowed properly once again, I pulled around and headed back toward the interstate, looking down into the field to see how much of the field she'd crossed. She was gone.

The Beats Go On

When the television series *Route 66* debuted on October 7, 1960, it got a lukewarm reception. Appearing after the second debate between Richard Nixon and John F. Kennedy, it went largely unnoticed, lumped alongside serial westerns and potboiler crime dramas in the public perception. But the weekly travelogue starring Martin Milner and George Maharis was actually on the cutting edge of both technology and popular culture, according to Katie Mills, a cultural critic and researcher from Los Angeles.

"*Playhouse 90* and those sorts of anthology shows that were popular at the time were broadcast live, so there was always this connotation that you were watching theater. *Route 66* was the first show to be shot entirely on location, and made very good use of the emerging technology," she said in a recent interview. In addition, while many television directors were trying to translate the long blocking techniques of theater to the small screen, *Route 66* often used a more cinematic feel, incorporating flashbacks and cinema verité-flavored camera work.

Mills, who received her Ph.D. in Film and Literature from the University of Southern California, also thinks *Route 66* was one of the first regular television shows to give Middle America a realistic portrayal of the Beat Generation, its concerns, and values.

"Beats were treated poorly by the mainstream media at the time, often made fun of. But they were so easy to parody," Mills continued, "They were in the right place at the right time. Just as television was looking for content, the Beats were willing to come on and be kooky. So in some ways it was their own fault.

Though rooms near the plaza are often expensive and booked far in advance, the El Rey Inn on the edge of Santa Fe offers luxury accommodations and lush gardens. Its classic adobe exterior is *de rigeur* for buildings new or old.

"Jack Kerouac was on TV a lot in those days, though he personally detested television. He was very shy in general and hated appearing on shows, so he would get drunk first. Then he would go on and be broadcast as this sort of drunken fool. It all became sort of notorious."

While many critics and scholars—Mills included—have long maintained the *Route 66* television series was inspired by *On the Road*, recently published papers show that the book's author also recognized themes in the show. "Kerouac wrote about the similarities in a letter," Mills explained." "He specifically mentioned *Route 66* and how he didn't like it." And if Kerouac liked it little, CBS program executives liked it even less.

"What the show tried to do in its first year, is much different than what it was told to do by CBS in subsequent episodes. Herb Leonard and Sterling Siliphant (the show's producer and main writer) were trying to produce a politically savvy, edgy series," said Mills. "But, and this is very well documented, CBS came back and told them they had to have more 'broads, bosoms, and fun.'"

To be sure, in its early episodes the series was politically charged and dealt with deeper issues than CBS might have cared to visit. Like *The Twilight Zone*, its thinly veiled morality plays often mirrored what was happening in society. The first episode, "Black November," dealt with a wealthy businessman who had murdered two German

The El Rancho Hotel in Gallup was once a home away from home for actors filming westerns in the nearby countryside. Today it is a required stop for those headed west on Route 66.

POWs as his neighbors watched, after learning his son had been killed in action. In another, Robert Duvall plays a heroin addict trying to kick his habit with the boys' help. Yet another deals with a Native American woman, pregnant after being raped by a white man. But the producers eventually knuckled under to network demands, and it was obvious, according to Mills.

"Leonard and Siliphant were a well respected TV team at that time. They were already producing the show *Naked City*, and a lot of very talented writers, actors and directors worked on *Route 66* before it was over. But you can really see a turn-around where they start introducing lots of guest stars such as Tuesday Weld, Suzanne Pleshette, or Julie Newmar, so there can be more of a romantic plot for these guys." And in addition to the network's insistence on showing a different kind of hip, changes in the show's cast would deal yet another blow to its unique dynamic.

When Maharis was forced to leave the show because of mononucleosis (aggravated by a contract

Over the years many film directors found the El Rancho's rough-hewn interior looked enough like an old West hotel to double as such in their films. While the glory days of the western have long past, TV crews often visit while filming Route 66 documentaries.

dispute say some), Milner teamed up with Glen Corbett, who played Linc, a recently returned Vietnam veteran. For whatever reason, viewers never really bonded with Corbett's character. Perhaps it was because Maharis' departure was too cutely written off in the script to be fully understood, or that no one had ever heard of Vietnam in 1963. Regardless, the show's ratings foundered and it was eventually cancelled.

"It captured the imagination of a lot of people," says Mills. "These guys were young, they didn't have jobs, and they're giving in to this feeling of wanderlust and discovery. I never saw the show as a kid, but knew it was something I wanted to write about."

And though she has written widely about the academic implications of the series, Mills has also driven the real Route 66 end-to-end. Back in 1991, before she was "too busy writing about road trips to actually go on road trips," she drove the old road from Chicago to L.A. "Route 66 is an important part of the postwar road story," she concludes.

In the end, *Route 66* the television series had little to do with Route 66 the road. All but a handful of episodes were filmed far from the old highway itself. But still, the series managed to capture the tinge of wanderlust the road invokes. It beckoned viewers not so much to drive Route 66, as to just drive—not so much to travel, as to explore.

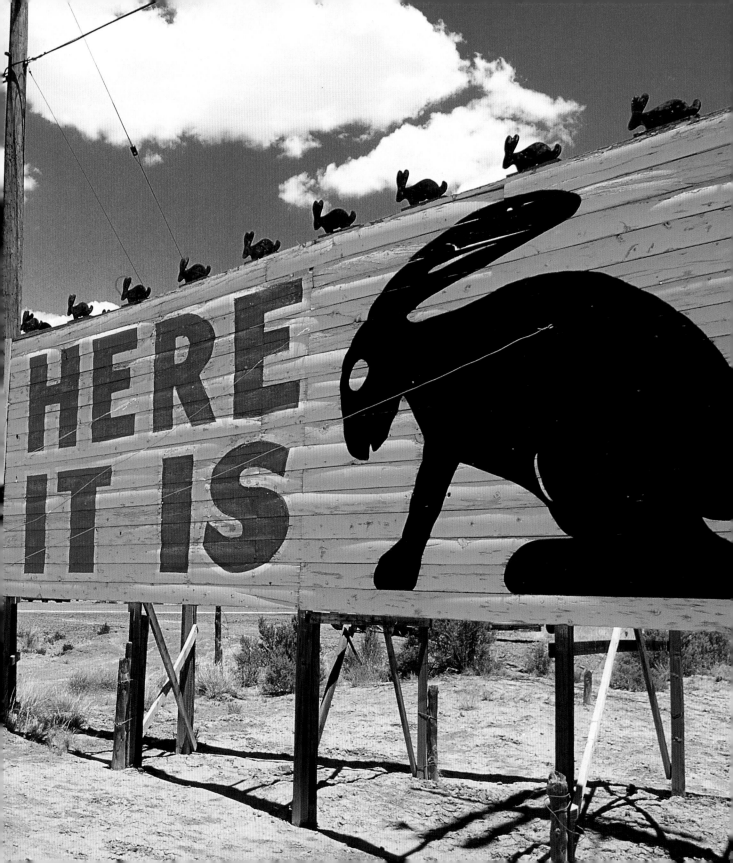

Whoever gave Montana the nickname "Big Sky Country" had obviously never been to Arizona.

Though it is a lighter shade of blue than the deep cobalt of New Mexico, the sky reaches on forever here, until you are certain you can see the curve of the Earth in the distance.

There are little tastes of what the old road was like in every state, but it is here in Arizona where Route 66 remains the purest. There isn't a lot of it, mind you, but what remains is the stuff of dreams. And like any good thing, you must wait for it.

The old highway all but disappears through the first half of Arizona. There are short sections that run for a few miles here and there, but unless you are an amateur archeologist in a four-wheel drive, it is easiest and safest to stick to the interstate for much of the eastern portion of the state. But even on the big road there is plenty to see.

Just off Exit 311 the Painted Desert and Petrified Forest loom north and south of the road, respectively, and an easily driven loop takes you through both parks before depositing you safely back onto Highway 180 at the southern terminus

CHAPTER 7

Arizona

Here It Is!

of the preserve. From there it's a quick shot into Holbrook and two unique opportunities for the Route 66 traveler.

The Pow Wow Trading Post deals in all things geological. They stock beautiful turquoise jewelry, legal pieces of petrified wood, and polished stones of every stripe. But in all honesty, they also have a lot of crap. Petrified dinosaur droppings to be precise. I had been looking for that perfect gift to bring back to the wife after this long trip, and after a little deep thought I realized this was not it. Just down the street, however, is something that has drawn travelers without reservations for years.

The Wigwam Motel is a true piece of Americana. There are only two left along the old road, and the one in Holbrook is by far the better for reasons you'll understand better once you get to California. "Have You Slept In A Wig-Wam Lately?" the sign asks. And just down the road from Holbrook sits another Route 66 landmark.

The Jackrabbit Trading Post's trademark yellow signs have lined the roadway since World War II. A simple silhouette of a jackrabbit, with the cryptic "here it is" written alongside, has puzzled travelers for years, and to the sign creator's credit, a good deal of them have stopped in to see exactly what "it" was. Few have been disappointed.

Although the town never made it into Nat King Cole's version of the Bobby Troup song,

The familiar yellow and black signs for the Jackrabbit Trading Post entice travelers for miles before they actually find out what "it" is.

"(Get Your Kicks on) Route 66," Winslow was immortalized by The Eagles many years later in the Jackson Browne song "Take it Easy." As a testament to the song, town officials have put in a "Standing on the Corner" exhibit downtown, replete with a girl in a flatbed Ford subtly painted onto a window, seemingly reflected from across the street.

There are many small towns along Route 66, but with a population of two, Meteor City ranks as the smallest. Centered around a large geodesic dome, the rough compound is a favorite stop

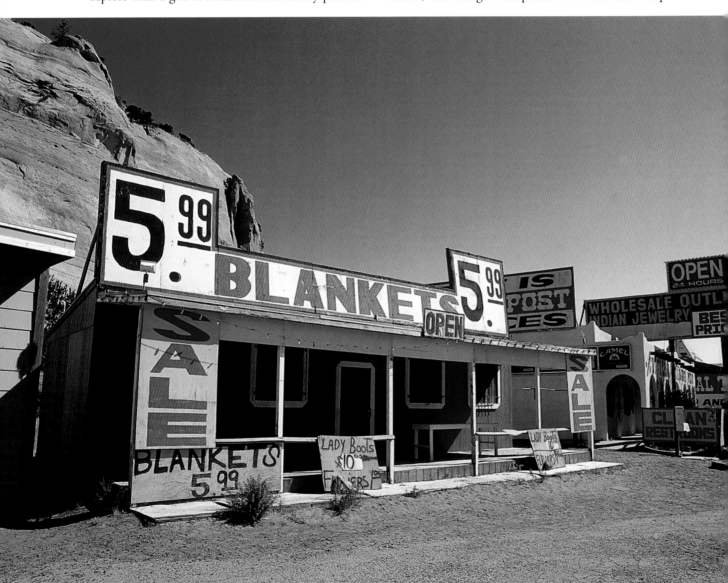

Sitting at the base of dramatic cliffs, the Chief Yellowhorse Trading Post near Lupton is the first stop for gas, cigarettes, and Navajo blankets once you cross the Arizona border.

along this stretch of the old road. You'll find a mixed bag of Route 66 souvenirs, petrified wood, and bric-a-brac related to the hole in the ground just up the road.

Six miles away, more than 20,000 years ago a meteor slammed into the desert floor, leaving a crater almost three miles around. In the late 1800s, a local merchant purchased the land, assuming the crater would yield a rich supply of iron ore. A shaft was dug into the floor of the crater, and the land did indeed produce ore for years. After the mine closed, the crater became increasingly popular as a tourist attraction.

Like many things along Route 66, the Painted Desert in eastern Arizona has to be seen to be believed. From observation points along a long looping drive, you can observe mountains more than 60 miles away with the naked eye.

Some 225 million years ago this section of desert was a vast flood plain. As dead trees soaked in silica-laced water, tree tissues crystallized. Today, the Petrified Forest is a perfect compliment to the Painted Desert a few miles north.

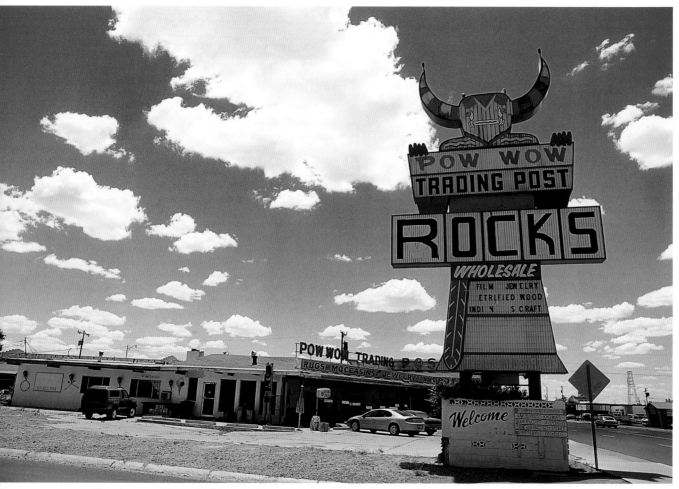

Though you can be arrested for removing even a splinter of petrified wood from the national park, a few miles away in Holbrook the Pow Wow Trading Post sells "legal" souvenirs, turquoise, and other Native American artifacts.

It is another one of those things one sees in an encyclopedia as a child, but is in no way prepared for in reality. Stepping out of the visitor center and onto the walkway that rims the crater, perspective takes a powder. Whatever references one uses to gauge the size of things—a person's height or the number of stories in a building—become moot as you peer down into the bottom of the pit.

When the United States entered the space race in earnest, Apollo astronauts trained in the crater, hoping it was a close approximation of the lunar surface. If you look carefully through one of the telescopes mounted on the crater's rim, you can see a plywood cutout of an astronaut holding a U.S. flag at the bottom of the crater.

As you approach the foothills of the San Francisco range, it's easy to see how the line "Don't forget Winona" came to be. The tiny burg just east of Flagstaff is mostly a memory now. Were it not for the fairly new cars parked in front of scattered houses, one could easily assume the place was deserted.

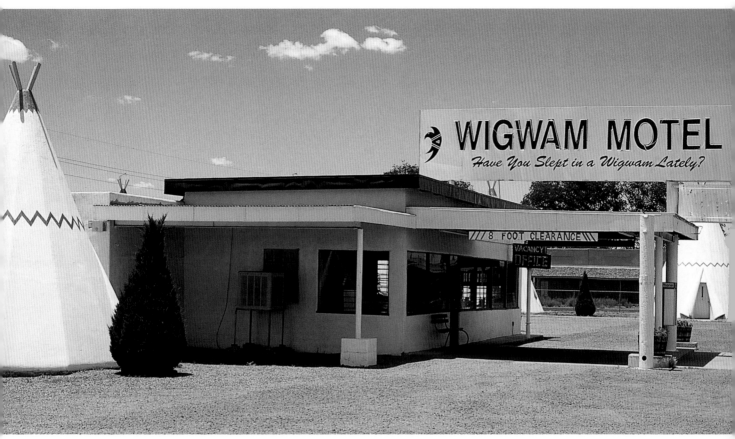

Just up the street in Holbrook, the Wigwam Motel is the last chance for families to stay in an authentic "wigwam." Although there is a similar motel in California, it has gone so far downhill it is not recommended for families.

Climbing into the mountains before Flagstaff, the temperature cools down, and thick pine groves line the roadside. Flagstaff itself is a fine, if unremarkable, city and it's easy to follow the old road through the city center.

We decide to push on into Williams before stopping for the night. It would be one of the best decisions of the trip. The old railroad center is full of history, good food, and cheap lodgings. Even on a weekday evening, the streets are full of people at outdoor cafés, and if there is anyone inside the city limits who is not in a good mood, they do a fine job of hiding it.

The Red Garter Bakery and Breakfast

If ever a town had a love/hate relationship with Route 66, it is Williams. The old logging town 30 miles west of Flagstaff bears the grim distinction of being the last place along the old road to be bypassed. It was here Route 66 officially ceased to be in 1984.

As you step inside the door of the Red Garter the aroma of cinnamon and fresh-brewed coffee wafts over you like a healing wind. Customers sit here and there, reading the newspaper and lingering over coffee, while at a long table near the back, proprietor John Holst chats with overnight guests.

Though gimmick postcards over the years have shown cowboys riding jackrabbits while herding cattle, this larger-than-life statue provides the perfect photo op for connoisseurs of kitsch everywhere.

Once a bustling saloon and brothel on the wrong side of Williams, the Red Garter now serves up coffee, pastry, and overnight lodging in the middle of a burgeoning historic district.

When he bought the building more than 20 years ago, it was a run-down warehouse full of used tires and batteries. It had deteriorated to the point that sunshine streamed through gaping holes in the roof. While it is sad to see anything dying from neglect, this particular building's rich and spicy history make it all the more tragic.

"It was built in 1897 by a German immigrant named August Tetzlaff," Holst explains. "He brought all the bricks and building materials in on a flatbed railcar and set it up as a commercial

Another roadside attraction, these oversized arrows often draw the attention of travelers skirting the edges of Twin Arrows, Arizona.

Proprietor John Holst had been looking for a historic property for years before purchasing what would become the Red Garter. A general contractor before becoming an innkeeper, he gutted and restored the building with loving care.

duplex. There was the bordello upstairs that was leased to a madam and a saloon on the first floor that he also leased. Then he put up a little shack out back where he ran his tailor shop."

Tetzlaff's tailor shop faced the town's more respectable business district, while his other enterprise, facing the railroad tracks, did a thriving business as well. The bordello operated under different names right up until the beginning of World War II, according to Holst, although it was a very low-key operation. "They were just called furnished rooms," he says with a grin. In the 1950s the building continued to be used as a rooming house for transients and others down on their luck, before closing and being used for storage.

In 1979 Holst was working as a general contractor rehabbing old buildings throughout northern Arizona and had been looking for a property with potential.

"I kept my eyes open, the same way you might look for a '57 Chevy sitting in someone's backyard. I was looking for a town I could get involved in and own one of these original pieces of history." He eventually found what would become the Red Garter in Williams and began slowly putting it back in shape.

Holst also became active in the community. As an experienced contractor with an eye for historic buildings, he quickly saw the potential Williams had. But in 1984 when it was announced Route 66 would finally be decommissioned, the town's attitude turned sour and many of its residents either left or simply gave up.

"Those were really tough years for us," Holst recalls. "We had to go from this 'grab it while you

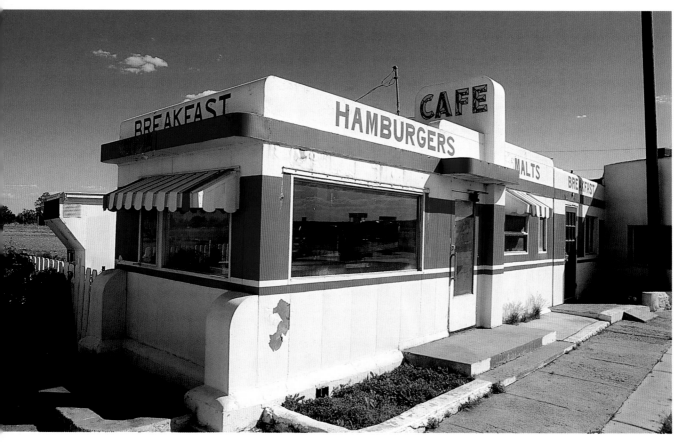

You can almost imagine the legion of truck drivers and traveling salesmen that must have had a quick plate of home-cooking at this café in Twin Arrows, before venturing back out onto Route 66.

can, they will never come back' mentality, to physically rebuilding the town and thinking about it in terms of inviting people back. We had to make it a nice enough place that people would be drawn here instead of simply passing through." And while making the downtown area into a historic district was a gargantuan task, changing the town's mindset was even harder.

"It was like pulling teeth," he continues. "A lot of the energetic people moved out, and the whiners and complainers stayed. So what we were left with was a lot of people who were willing to sit back and let others come in and rebuild it." And over the course of a decade, they did just that.

Today, thanks to Holst and many others, Williams is a budding destination community. A vintage rail line takes tourists to the southern rim of the Grand Canyon every morning, a steady stream of Route 66 pilgrims flow through town, and the saloon row that was once the town's shame is a quaint historic district. But the piquant history of the old brothel has not been forgotten.

Lining the wall of the Red Garter are pictures of female guests, draped in red feather boas and winking seductively, or dangling stocking-clad legs from the second-story window while crooking fingers at the camera with a come-hither smile. And though present-day guests revel innocently in the

bawdy history of the building, occasionally a ghost from the past reappears. Not long ago an elderly man showed up at the Red Garter and presented its proprietor with a faded red tablecloth.

"He had come in on a freight train years ago, as a hobo," Holst explains. "He paid his two or three dollars for a room for the night, and when he left the next morning he took this cloth that one of the girls used to cover a table, and wrapped his belongings in it when he jumped another train for California. He had kept it all these years and wanted to return it."

Mining Towns

West of Williams, the old road pushes far away from the interstate and up into the desert. Passing south of the Aubrey Cliffs and on through the Hualapai Indian reservation, Route 66 seems stuck in time. There are few cars traveling this stretch, and stepping out onto the hot blacktop it's easy to imagine Okies in broken-down Fords, GIs waiting expectantly with outstretched thumbs and heavy duffels, and long white Cadillacs racing across the desert toward Las Vegas.

A fake squirrel eating a snake atop a plate of burgers is just one sign of Juan Delgadillo's slapstick sense of humor. Visitors are never quite sure what to make of the prankster, who has been pulling gags at the Snow Cap restaurant on Route 66 through thick and thin for decades.

The few towns that remain are little more than wide spots in the road, a few houses and a general store selling cheap beer if even that. Rocky hills shoot up on either side of the road and the sun bakes the ground unmercifully. The last stop before pushing back south toward Kingman is the tiny village of

The Snow Cap's company car sits festooned with just about everything outside the landmark attraction in Seligman. Occasionally, Juan starts it up, producing great belches and backfires, just long enough to drive across the street.

Inside the Snow Cap, customers jam into the narrow entry to place orders, dodge dime store gags, and enjoy one of the great goofy characters along this stretch of Old Route 66.

Hackberry, site of an old silver mine and home to the infamous Route 66 Visitor Center.

It was run for years by Bob Waldmire, a traveling artist best known for his incredibly detailed "bird's-eye view" map of Route 66. Waldmire's outpost was part archive, part firetrap but still a popular stop for tourists from around the world. One of the road's most colorful characters, Waldmire could

often be found driving somewhere along the old road in his "Un-official Route 66 Mobile Information Center" (a bright orange Volkswagen van covered in old highway signs and bumper stickers imploring people to become vegetarian, legalize marijuana, and the old favorite, "Question Authority"). But Waldmire eventually tired of the daily grind and decided to move back to Illinois.

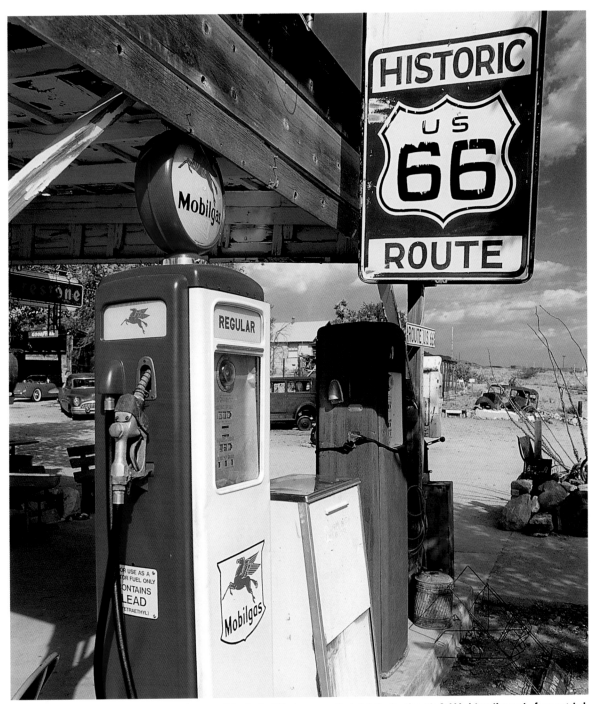

The Route 66 Visitor Center in Hackberry is one of the funky little treasures that dot the Southwest. Cobbled together out of corrugated tin and good intentions, it is under new ownership these days, but remains true to the spirit of its former owner, artist Bob Waldmire.

West of Kingman, Route 66 goes native. None but the brave attempt the primitive road as it winds up into mountain passes and abandoned gold fields. The burned-out hulks of cars at the bottom of passes serve as silent reminders to slow down.

In the old mining town of Oatman, burros roam the streets freely. Decades ago, a pack was set free by miners and has been reproducing in the hills ever since. Many shops have signs imploring tourists not to feed them anything but oats, since they tend to metabolize anything else quickly.

In 1998 he sold the center to John and Kerry Pritchard, a Washington couple who had visited the place and fell in love with it.

While the Pritchards have tidied up some of Waldmire's trademark clutter, the Route 66 Visitor Center retains all of the relaxed charm of its former owner. Though they had planned to renovate the front of the place, people begged them to leave it just as it was.

If the lore of Route 66 seems as rich as a novel at times, perhaps it is because, like a good novel, it reaches its denouement very close to the

end. The slow grade into Oatman is full of hairpin turns and white-knuckle mountain passes. The desert falls away beneath you as you climb through used-up gold fields and abandoned mines. When you finally reach the turnout near Sitgreaves Pass you'll feel inclined to get out and walk around on solid ground, like a sailor returning from an extended voyage at sea.

Just down the side of the mountain a rusted car body lies smashed headlong into the sheer face, the rock above still black from the fire that must have erupted on impact. Below it, a Volvo station wagon, farther still an unrecognizable red ball of steel, and at the very bottom, the back half of a pickup truck lies a few hundred yards from its mangled mate. Near the edge of the cliffs rough-hewn wooden crosses serve as both memorial and warning.

There's still gold in these hills, but what comes out today is a mere trickle compared to the region's glory days. When World War II started, some of the mines were declared nonessential to the war effort, and summarily closed. While many of the miners packed up and left, the few families that stayed have carved a hearty if hard life out of what opportunities remained. But while the human population of Oatman might have dropped, another group has thrived.

Burros were long used by both mines and individual prospectors to carry equipment in and gold out of the hills. When the mines began closing the animals were set free into the mountains, where they have been reproducing ever since. And while the burros roaming the streets of Oatman are descendants of that first generation from the mine, they have grown used to a softer existence.

You smell them before you see them, wandering up and down the narrow main street, licking spilled ice cream from the pavement, begging carrots or oats from obliging tourists and taking cool drinks from children's wading pools. Shopkeepers swat them away from their open doors like a neighbor's errant cat.

Cactus Joe's Cantina in Oatman is built around a huge Saguaro in the center of the room. Inside, a favorite lunch item is the "Stinkin' Garlic Cheeseburger," a patty fried in garlic, topped with garlic and mushrooms, and served with a clove of garlic garnish.

We drop down out of the mountains and cross the Colorado River into California. Luckily, the guardhouse ahead is not turning away refugees. They just want to know if we have any fruit.

Southern California is probably the most photographed real estate on the planet. Since the American film industry sprung up on the edge of Los Angeles in the 1920s, everyone from Laurel and Hardy to *Baywatch* has used the varied terrain as a backdrop. So even if you didn't grow up in California, odds are you spent a good deal of your youth goggling at it on television.

For that reason, by the time you roll into the northern edges of Los Angeles County you have a vague feeling of déjà vu. You recognize the storefronts and skyscrapers and the dull brown haze that hangs over downtown. But before one gets to the palm-lined boulevards of Beverly Hills, or the omnipresent freak show in Venice, you've got to cross the desert.

It is at once alien and familiar. Full of slashing bluffs, dust devils and scrub bushes, the Mojave is neither the pure sand desert you expect nor the Martian landscape it so often approximated in 1950s science fiction movies. But it is hard land all the same, and if it feels this brutal in an air-conditioned van, then crossing it in a Model T or Conestoga is unimaginable.

Once a kitschy stop along Route 66, the Wigwam Motel near Rialto had deteriorated into a dive used mostly by the prostitutes working the street in front.

CHAPTER 8

California

The Garden of Eden

On the west edge of Needles, you rejoin I-40 for a spell, before exiting and rejoining the old road. Route 66 arcs north through the old town of Goffs before curving south again toward Amboy. And as you pass under the interstate, a railroad track runs high on an embankment on your right. Against its side fellow travelers have left their mark.

Spelled out in stones laid carefully into the steep grade, the messages are simple: a name or two, perhaps just initials. The most ornate (obviously done in the cool of the morning) have names and dates and offer universal slogans such as "Cruisin'!" and "Gettin' our kicks." Most are legible, although a few have lost their hold in the sandy soil.

The old road continues on through Essex, Chambless, and Amboy, making a long dip south skirting the rims of dried-out lakebeds. Though the remains of the town of Bagdad are on this stretch between Amboy and Ludlow, the movie *Bagdad Café*, which sparked much German interest in the old road, was actually shot a few miles farther on, in Newberry Springs.

As you drive south and west out of Barstow, you pass through the last of the Mojave and the last section of open road on Route 66. Soon it will be into the urban sprawl of Los Angeles, where the old highway traverses barrios and bedroom communities. But before the journey draws to a close, there's one last bit of history, just outside of Helendale.

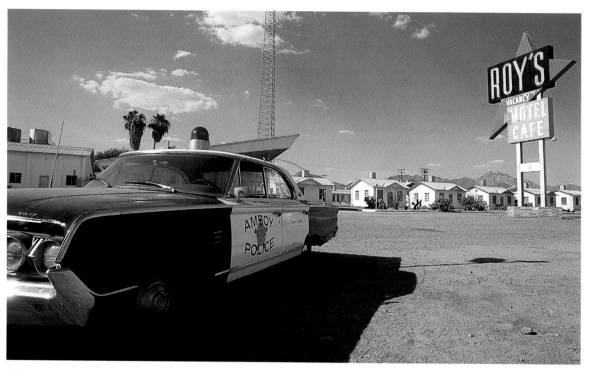

A vintage police car sits parked outside Roy's Motel and Café in Amboy, California. The Mojave landmark has long been a stop-off for travelers and servicemen from the nearby Marine Corps training facilities, and often shows up in print ads and television commercials.

Exotic World Burlesque Museum

Down a bumpy road on the edge of town, a set of tall white columns marks the entrance to the Exotic World Burlesque Museum, home of the "Movers and Shakers." As we follow the sandy lane down into a compound of outbuildings and trailers, former stripper Dixie Evans is taking it off. She's taking it all off.

"You *would* show up when I'm scrubbing out my microwave," she says, deftly removing a pair of rubber gloves and pulling up a chair at a shaded table outside the museum.

At 75, Evans is, in the finest sense of the words, a classy broad. She moves gracefully, quoting Aristophanes as easily as Groucho Marx, pointing out displays and hitching up her pants with an air of self-assuredness no mere 70-year-old could muster.

She was born Mary Lee Evans in Long Beach in 1926. He father died when she was a child, leaving Mary Lee and her mother alone. She set out to become a dancer, hoping to land a slot in a chorus line. And though those goals proved elusive, Evans finally got work as a page in a musical review.

"Oh it was easy enough work," Evans recounts. "You had a cute little costume and every once in a while you walked out with a card listing the next act or pulled back the curtains as the shows began." Evans went on the road with the show, but it went broke a few weeks later, and she found herself stranded in San Francisco.

"Well, one of the girls mentioned there was a strip place up the street," she recalls with a raucous laugh. Evans signed on to work at the club, where she found great friendship and support from her fellow

dancers and launched a new career. "It was the beginning of a whole new beautiful world for me."

In Evans' heyday, many of the performers were billed as look-alikes of famous actresses. "We had the Loretta Young of burlesque, the Lauren Bacall of burlesque, the Sophia Loren of burlesque," Evans recalls. "I was the Marilyn Monroe of burlesque."

Indeed she was. The fading black-and-white publicity photo on a museum wall shows Evans in a beaded dress and heavily made-up, younger but just as blond, posing as Marilyn. The resemblance is uncanny.

Unlike the gentlemen's clubs and porn houses of today, the burlesque theaters in which Evans worked attracted both men and women. While never considered high art, the risqué skits were often biting social satire, skewering figures out of the day's headlines. One of those figures was Joe DiMaggio, who had recently divorced Hollywood's hottest starlet. And while a true statistical analysis might tell a different story, even a fleeting belief in fate leads you to believe that sooner or later "the Marilyn Monroe of burlesque" would collide with the real-life Joe DiMaggio. Eventually, she did: in Florida.

Evans was doing her Monroe act in a Miami Beach nightclub when the manager came to her table and told her DiMaggio was there and wanted to meet her. She told him it would be rude to leave the person with whom she was sitting, and Mr. DiMaggio would have to come back another time. But after some prodding from both her friend and the manager, she finally agreed to sit with Joltin' Joe.

"He was sitting at a table with Grantland Rice, the sportswriter, and Skinny D'Amato, who ran the 500 Club in Atlantic City," Evans recalls. "They were sitting around cracking jokes and such."

She enjoyed a drink and a few laughs with DiMaggio and his friends, but became increasingly uneasy about performing her Monroe impersonation with him there. The couple had just divorced, and Evans' routine made great sport of DiMaggio.

Though the old town of Bagdad is little more than a memory today, the Bagdad Café in Newberry Springs was the inspiration for both a movie and short-lived television sitcom. The story of a Bavarian woman who leaves her husband and stays to work at the restaurant is extremely popular throughout Europe.

"He said, 'Go ahead, I don't mind,' but I was still just shaking in my boots, " she says. But ever the trouper, she mustered up her nerve and went on. Standing up and backing away from the breezeway table, Evans lights up as she goes into the act she performed so long ago.

Oh Boo hoo hoo…why shouldn't I cry?
Joe, you walked out and left me flat.
You didn't want me anymore: you left no doubt
of that. So now you're gone and I'm all alone,
Thank heavens you left your bat!

Evans grabbed DiMaggio by the tie and dragged him into the spotlight with her as she continued the sex-kitten routine. "He had to be halfway embarrassed, being pulled out there in the spotlight with me like that," Evans laughs. But ever the gentleman, DiMaggio took it all in fun.

Evans' friend, Jenny Lee, originally started Exotic World. Also a former burlesque dancer, Lee

Dixie Evans, once billed as "The Marilyn Monroe of Burlesque," runs the Exotic World Burlesque Museum on an old goat farm outside of Helendale. Once a year she sponsors a Miss Exotic World Pageant, reuniting performers from the golden days of burlesque.

Though there are still plenty of girls out there willing to take their clothes off on stage, and a flourishing gentleman's club circuit to employ them, Evans thinks they bear little resemblance to the glory days of burlesque. "You can't compare Grandma's old iron skillet to a microwave," she laughs.

The End of the Road

South of Victorville and on through San Bernardino, there are few unspoiled pieces left of the original road, and any enjoyment you get from finding them is balanced by all the backtracking through city streets one does to get there. And descending down out of the mountains and into the Inland Empire region of suburban L.A., there is a tinge of regret that the journey is almost over.

Route 66 becomes Foothill Boulevard here, passing through Rialto, Rancho Cucamonga, and Upland. The Wigwam Motel sits just north of the road on the edge of Rialto, mirroring the Wigwam Village back in Arizona, but its southern California cousin has seen better days. The pool is cracked and empty, and the desk attendant waits in a darkened room behind bulletproof glass. Once a stop for families on their way to Disneyland, the motel's only customers these days are prostitutes and the people who employ them.

From here on, Route 66 is a confusing hodgepodge of different possibilities. A left turn could take you down the route from the 1930s, while turning right might mean a trip down the 1950s alignment. And while there are still historic points along the way, it is all city driving, maddeningly slow and mostly uninteresting. Soon the glory and history of what was Route 66 becomes the glitz and smog and noise of Los Angeles.

The Mayor of the Mother Road

Almost before they had pulled up the last markers on the old road, there were already groups plotting to save Route 66. While there have been government dollars put into play here and there,

owned several nightclubs and had become quite successful off the stage before being stricken with cancer. Lee sold her clubs, and moved to the desert for the less stressful lifestyle. Evans visited often, and eventually stayed on to care for Lee and the fledgling museum. Although Lee passed away a short time later, Evans has kept her dream alive and growing. No small feat, since entry to the museum is free.

"I don't know where the money comes from, but we just keep going," Evans explains. While Exotic World contains many rare items—Sally Rand's fans, a beaded dress of Marilyn Monroe's, and Jayne Mansfield's heart-shaped divan—Evans would like to expand it even more, turning it into a Hall of Fame for performers from all over the world.

When Dixie Evans' friend and fellow dancer Jenny Lee was diagnosed with cancer, she sold her nightclubs and moved to the high desert for the relaxed lifestyle. As her health failed, Evans moved in to help care for her, and took over the operation and expansion of what became Exotic World.

Jayne Mansfield's heart-shaped divan is one of many rare exhibits housed at Exotic World. Performers and collectors alike often donate items to the museum, believing they will be in their rightful home.

the effort to resurrect 66 is mostly the work of regular folks. State by state, mile by mile, they've slapped on a coat of paint here, held a fundraiser there, and coaxed a few dollars out of the county highway departments everywhere. Like a good old-fashioned barn raising, Route 66 is being put back together a mile at a time by its neighbors. And if Route 66 is indeed the "long, thin town" songwriter Kevin Welch describes, then its mayor is undoubtedly Angel Delgadillo.

Delgadillo, a soft-spoken barber from Seligman, Arizona, was born on a dirt road that would become 66 in 1927. One of nine children, he attended school in Seligman before venturing off to the Pacific Barber College in Pasadena, California, also on Route 66. After graduation, he got an apprenticeship at a small barbershop in Williams, Arizona, also on Route 66. When it came time to venture out on his own, Delgadillo returned to Seligman and starting cutting hair in a one-chair

Designed by Robert Stacy-Judd in the 1920s, the Aztec Hotel in Monrovia is on the National Register of Historic Deeds. Judd designed several other area buildings, including the Masonic Temple in Tujunga, First Baptist Church of Ventura, and the Atwater Bungalows in Elysian Park.

shop on Main Street—also Route 66—where he's been ever since.

Having spent his entire life along this stretch of Old Route 66, one can only guess at the heartache Delgadillo must have felt as he stepped out of his shop and looked at Main Street on September 22, 1978, the day traffic was officially redirected off Route 66 and onto I-40 to the south.

"All through that last summer you had to run just to get across the street. The traffic was so heavy: 9,000 cars every day," Delgadillo explains. "Then, it was gone. You could lay down and go to sleep in the middle of Main Street if you wanted. It was completely dead."

Delgadillo knew the historic role Route 66 had played not only in Seligman's past, but the nation's. And while many people in the towns along this old stretch were preparing for the worst, Delgadillo refused to join them. Instead, he became an evangelist, gently prodding people to band together and lobby state officials to grant the road historic status.

"They thought we were nuts," he says, beaming. "But we had to do something, and stick together. That's why we formed the Historic Route 66 Association of Arizona. Now there are groups in every state and all over the world." Delgadillo, though simply trying to save the town to which he had devoted his life, started a movement that spread up and down the length of Route 66 and around the globe.

For that reason and many more, Delgadillo has become a beacon for Route 66 travelers. Every day, people pull into Seligman wanting to meet the man they read about in a book or saw in a video or interviewed on television. And if by chance Angel isn't there, another member of the Delgadillo fam-

ily is there to greet them. Just down the street from the barbershop, Angel's older brother Juan runs the Snow Cap. Part drive-in, part vaudeville routine, the wildly decorated restaurant is impossible to miss as you roll into town.

Juan is fond of jokes. Nothing sophisticated, mind you: dime store gags, melted forks, or wads of dirty napkins will do just fine. He uses them all to great effect on the stream of Route 66 travelers passing through.

Pity the poor European tourist who finally gets his order out in broken English, only to get fake mustard squirted at his wife, his change given to someone else. And the menu is as comic as the Snow Cap's proprietor, offering "Cheeseburgers (with Cheese), Hamburgers (no ham)," and the ever-popular entree, proudly displayed in large letters on a sign out front, "Dead Chicken."

There are thousands of images that depict Route 66 as it once was. The stark black-and-white images taken during the Depression by Dorothea Lange, the dusty prose of Steinbeck, and the wise-cracking blues of Woody Guthrie all contribute in a way. Yet, if there is a definitive picture of all this old road once was, and continues to be, it is Main Street Seligman on a Tuesday afternoon.

The street is mostly quiet, save for a trickle of Route 66 travelers coming mostly from the east. At the Snow Cap, pennants flap in the breeze, buoyed by the smell of grilling burgers. Just up the street, Angel Delgadillo neatly folds his apron and lays it on the barber chair his father bought in 1929.

"I started telling people about six months before I was going to retire: 'You're going to have to find another barber,'" he recalls. "I'm still going to be coming in here every day, and you might see me cutting hair once in a while, but it's all public relations work." And true to his word, he often

On Mission Street in Pasadena, the Fair Oaks Pharmacy serves up old-fashioned sundaes and ice cream sodas from behind their vintage counter. In addition to its retro soda fountain, Fair Oaks is still a working drugstore filling as many prescriptions as egg creams.

The Mayor of the Mother Road. Angel Delgadillo, a gentle barber from Seligman, Arizona, founded the first Historic Route 66 Association and is responsible for much of the preservation work that followed. People from around the world travel to Seligman to visit his shop and meet him in person.

The ferris wheel on Santa Monica Pier is one of many carnival rides that attract tourists and locals alike. Like Roy's back in Amboy, the pier is a favorite location for both amateur and commercial photographers.

Though Route 66 technically ended a few blocks away, the Santa Monica Pier has become a symbolic last stop for a generation of Route 66 pilgrims. As night falls over the Pacific, a stream of traffic departs, leaving only the hardcore fisherman and barflies behind.

obliges visiting tourists, writers, and photographers with a haircut or shave.

The souvenir shop next door connects to his shop, and every few minutes someone will poke their head in, ask if they can have his autograph or take a picture. He refuses no one. He has grown to expect the pilgrims, and though he is never sure just how many will arrive on a certain day, he knows they will always come.

Delgadillo's life story and the history of Route 66 are intertwined, almost to the point of being one. Sadly, more of his life is behind him now than ahead, and when people reach that

point that they often reflect on what was, and what could have been. As a barber, he could have worked anywhere in the world, but instead returned to his hometown. When he retired, he was cutting the hair of the grandchildren of his first customers. And the smile on his face as he relates that fact leads one to believe he is comfortable, if not proud, of the choices he made as a young man.

The rebirth of interest in Route 66 would not have happened without Angel Delgadillo. The Route 66 community, the town of Seligman, and the world will be a poorer place without him.

There is a damp chill on the Santa Monica Pier. The maze and haze of Pasadena, Los Angeles, and Beverly Hills (where, incidentally, we saw neither swimming pools nor movie stars) are long behind us, as are the thousands of miles of the United States we traveled.

Seagulls squawk above, diving occasionally after a fisherman's bait while music from the ferris wheel booms loudly in the distance. As the sun begins to set over the Pacific, we both sit silently, reflecting on the trip.

There are hundreds of things that come to mind: the face of the tree-trimmer in Amarillo who turned out to be an incredibly talented stencil artist, a couple in Oklahoma having a plate of barbecue and the way the man caressed the back of his wife's hand as he slid her a toothpick, and the look on the face of a little boy in a Mojave diner, whom we had just bought a soda, as his father took it away from him and drank it himself.

We've done our best to give you a flavor of what Route 66 is like today and what it might have been like in the past. Though it is a sad admission for a writer to make, words alone can't do justice to the power held in that old, crumbling pavement.

If you ever have the chance to drive it, as an athletic shoe company might say: Just do it. Take along some good maps, but don't concern yourself with staying on the exact alignment from 1926, 1936, or 1956. Pick your way along as best you can. If the road looks good, take it. If you are unsure, turn around and go back. And if by chance you're traveling with a photographer who has a brand new compass he is itching to use, throw that sucker out the window first chance you get.

Thanks for coming along.

Epilogue

INDEX